IMAGES
of America

GRENVILLE BAKER BOYS AND GIRLS CLUB

EDITH HAY WYCKOFF, LIFELONG SUPPORTER. From the beginning, Wyckoff's support remained strong. Each Thursday, she published accounts of the club's progress in the *Locust Valley Leader*, acting as both cheerleader and conscience. Wyckoff criticized anyone who questioned the club's value while encouraging the boys to demonstrate their appreciation and earn their community's respect. (Courtesy of Grenville Baker Boys and Girls Club.)

ON THE COVER: THE CLUBHOUSE. From the original building in 1950 through the many expansions over the next seven decades, time spent with friends remained the club's main attraction. Whether at the front door or inside the clubhouse, boys gathered with friends. Bradley Delehanty's design provided a welcoming space to meet with its great room, fireplace and beamed ceiling, library room, and additional rec room in the basement. (Courtesy of Grenville Baker Boys and Girls Club.)

IMAGES
of America

GRENVILLE BAKER
BOYS AND GIRLS
CLUB

Amy Dzija Driscoll and
Carol McKey Harrington
Introduction by Ramon Reyes

ARCADIA
PUBLISHING

Published by Arcadia Publishing
Charleston, South Carolina

Printed in the United States of America

Library of Congress Control Number: 2024942349

For all general information, please contact Arcadia Publishing:
Telephone 843-853-2070
Fax 843-853-0044
E-mail sales@arcadiapublishing.com

Visit us on the Internet at www.arcadiapublishing.com

SHERMAN AND E. DEMING PRATT, 1952. We dedicate this book to Sherman Pratt whose leadership, vision, and generosity laid the foundation and established the club's legacy for generations to come. Every so often in history, the right person steps forward at the right time. For Grenville Baker Boys and Girls Club, that person was Sherman Pratt, the rarest of individuals—a truly great man. Looking back at his many talents and virtues, what is most striking is his warmth and his kindness. Here, Sherman Pratt savors a moment with his daughter Deming. (Courtesy of Deming Pratt Holleran.)

CONTENTS

ACKNOWLEDGMENTS

We are overwhelmed with gratitude for the staff, alumni, and friends of Grenville Baker Boys and Girls Club who so generously gave their time, talents, and memories to bring this book to fruition. Initially conceived as a platform to celebrate the club's 75th anniversary, we soon realized that 75 years of activities, events, and continued expansion and growth could not be contained in one book. Therefore, with some reluctance, we chose to focus on the first 35 years of Grenville Baker Boys and Girls Club. For their advice, encouragement, and photographs, we are indebted to ATD Research, Marc Bilbrey, Nadine Buccilli, Guy Caruso, Peter Colgrove, Lorraine Dalton, Ken Deecken, Doug Derancy, Betty Dykstra, Billy Eliseo, John Evans, Bob Faller, Sarah Fletcher, Tony Gallego, Jan Guga, Jan and Rich Hagner, Bob and Susan Harrington, Ron Hinckley, Scott Hinckley, Deming Pratt Holleran, Chris Howell, Margaret Johansen, Woody Lewis, Locust Valley Library, Kevin and Patti Lohrius, Patrick Mackay, Brooks Magee, Paul Mateyunas, Harry McGinley, Colin O'Donnell, Ray Reyes, George Shaddock, Billy Simons, Eddie Simons, Smithers Foundation, Jill Stimola, Christine Thomaides, Helen Uber, Diane Wade, Randy Waskawic, Lori Yammond, Steve Young, and the "You Know You're From Locust Valley" and "Fans of Pratt's Camp" Facebook groups.

Finally, we would like to thank our families Tim, Maddie, and Timmy Driscoll; Alan and Marcia Dzija; David; Natalie; Hayley and Sam Harrington; and Reid, Winifred, and Clark Pauly for their unwavering patience, support, and love. Together, we also thank Sasha, Quinn, and Mallomar who collectively were an antidote for our stress eating and served as an excuse to get together. Photographs from private collections are credited as such. All other images are from Grenville Baker Boys and Girls Club.

INTRODUCTION

Founded in 1950 by the residents of Locust Valley, New York, Grenville Baker Boys and Girls Club stands as a hallmark of a small town at its best. The club is a rare gem, providing a safe place for local kids to play, to learn, and to thrive after school. Situated at the center of this north shore hamlet, the club is a testament to its community's firm sense of tradition combined with its enduring commitment to building for a better future.

The history of Locust Valley reaches back centuries to the days when the Matinecock tribe inhabited the area and to the mid-1700s when the first colonists arrived from England. These early settlers prospered as farmers, clammers, fishermen, and millers. By 1869, the railroad line from New York City was built. Local businesses grew up around the new train station, creating the Locust Valley commercial district where the club stands today. With the railroad also came wealthy families from the city who purchased large tracts of land to build their weekend country estates.

Families such as the Pratts, Cravaths, Guthries, Doubledays, and Davisons, drawn by its quiet natural beauty, built large manor homes along the winding, tree-lined roads of the north shore with its expansive views of the Long Island Sound. They established exclusive clubs such as the Piping Rock, Creek, Beaver Dam, and Nassau Country Clubs for social gatherings and athletic pursuits throughout the year, ranging from polo and golf to tennis and ice hockey.

The seclusion of the community, though prized by residents, forced local families, both wealthy and working class, to rely on each other to solve such challenges as mosquito control and poor roads. Forming the Matinecock Neighborhood Association in 1908, residents joined forces to create a fire department, library, and community house. Looking beyond local needs, in the wake of the Great Depression and World War II, community volunteers founded Operation Democracy, adopting Sainte Mere Eglise, the first town in France liberated during the Allied invasion of Normandy, further expanding Locust Valley's history of citizens responding to a need and filling it.

In the late 1940s, with Long Island's expanding population and the advent of such modern conveniences as central heating and automobiles, the people of Locust Valley experienced a change. People of all ages had more leisure time. Children were no longer needed at home to do chores such as chopping wood, toting water, and minding younger siblings.

With the advent of free time, community leaders recognized a new challenge when they saw a group of boys playing football near the railroad tracks in town and decided that these children needed a safe place to congregate after school. In 1947, the need to channel youthful energy into positive activities rather than mischief inspired the creation of a boys club in Locust Valley.

After several attempts to find a location for the club, Edith Kane Baker and her family offered to donate the funds needed to purchase the land on Forest Avenue and to build the original clubhouse designed by Bradley Delehanty. The Baker family was renowned for their generous donations to Harvard Business School, Dartmouth College, Columbia University, and Amherst College, to name a few. On December 5, 1950, the dedication of Grenville Baker Boys Club took place in memory of Baker's son Grenville, a decorated Army Air Corps pilot who had tragically died after the war.

The club founders recognized immediately that for the club to thrive they would need to find the right people to run it, to organize the programming, and to attract and retain the interest of local youth. On August 1, 1950, the board hired William Hinckley, a recent graduate of Boys Club of America's training courses, who assumed the duties as the club's first executive director. Under his direction, boys signed up to become the first members, happy to have a place to play football, watch movies, shoot pool, and spend time with friends. There were dances, tournaments, and field trips, in addition to summer activities that expanded to include Camp Small Fry and Pratt's Canadian Camp.

With the expansion of programming came the need to expand the facilities beyond the original clubhouse. In 1953, a lighted, hard-surface outdoor play area with a basketball court was added, and in 1956, a new gymnasium was built. With this new space, club membership rose to 350 boys. In June 1959, the Charles G. Cushing Memorial Athletic Field was dedicated, providing the club with its own space for outdoor sports. That same year, E.C. "Woody" Lewis joined Grenville Baker Boys Club as athletic director and eventually succeeded Bill Hinckley as executive director.

Reflecting the changing times and the evolving needs of the community, on May 20, 1981, the Grenville Baker Boys Club merged with the Girls Club of Locust Valley to form Grenville Baker Boys and Girls Club. To accommodate the needs of the new female membership, a new addition was constructed and dedicated in 1983. With the increase of both single-parent households as well as homes where both parents work outside the home, the after-school programs were expanded to include more access for kids to homework help and technology.

As the world has changed since 1950, the club has also changed, adapted, and evolved, with the fundamental mission remaining the same: to enable and inspire the youth of our community to realize their full potential. In today's world, the need for alternatives to drug and alcohol abuse has never been greater, particularly during the teen years.

The club continues to serve the children of Locust Valley across the economic spectrum. The ties that bind generations of club members and volunteers enrich the club experience and strengthen the community support for the club. With a recent renovation and expansion of the clubhouse, the future for the club and today's members looks bright.

–Ramon Reyes
Executive director (1991–2024)
Grenville Baker Boys and Girls Club

One

BEGINNINGS

In 1946, the owner and founder of the *Locust Valley Leader*, Edith Hay Wyckoff, noticed boys playing by the railroad tracks and decided they needed a safer place to play. Roy Peterson and his friends filled hours after school playing football on the cement parking plaza at the Locust Valley railroad station. Wyckoff encouraged the boys to form a club and offered her office nearby as a meeting place, creating the Bluejacket Club for the older boys and the Locust Valley Athletic Club for the youngsters.

Peterson also shared the boys' hopes for a club with Milward "Pidge" Martin, Locust Valley resident and chief attorney and treasurer of Pepsi-Cola. That year, Pepsi-Cola chairman Walter Mack challenged his company executives to establish Boys Clubs in their communities. Founded in Hartford, Connecticut, in 1860 to help disadvantaged boys, Boys Clubs of America had grown to a nationwide organization by the 1930s. Intrigued, Martin shared the news of this challenge with Wyckoff and Peterson, and the idea of forming a nationally affiliated Boys Club in Locust Valley was born.

With the help of area residents Sherman Pratt and R. Brinkley Smithers, Wyckoff formed a board establishing the Associated Boys Clubs of Locust Valley. Finding land with space for athletic fields and a clubhouse was the biggest challenge. While the boys continued to play on borrowed fields, the new board wrote to friends, asking them to become founding members, and appealing to the community for support. Because of their efforts, the response was both gratifying and generous.

Hunt T. and Elizabeth Dickinson offered to donate six acres of land at the corner of Birch Hill and Ryefield Roads, but local zoning laws prohibited its use for a club. In 1949, the club's hopes were fulfilled when Edith Kane Baker offered to donate the funds to purchase land and to build a clubhouse at the corner of Forest Avenue and Weir Lane in memory of her son Grenville Baker. By December of the following year, Grenville Baker Boys Club was built and dedicated.

LOCUST VALLEY LEADER EDITOR. In 1946, longtime resident Edith Hay Wyckoff published the first edition of the local newspaper, the *Locust Valley Leader*. Working from Hayfever, the home of her parents Helen and Tom Hay on Birch Hill Road, she welcomed readers to "drop by for a chat." Her earliest visitors included teenage boys like Roy Peterson, whose family lived nearby.

HAYFEVER, CLUB'S FIRST HOME. With nowhere else to go, Roy Peterson and his friends gratefully accepted Wyckoff's invitation to meet in her office. The boys helped tend the *Leader*'s potbellied stove, painted the walls, ran errands, and played pool. As they soon outgrew the premises, the hunt for a permanent home for their club began in earnest.

CHANGING TIMES. In the aftermath of the Great Depression and World War II, locals questioned the need for a club, remembering their own childhood when chores kept them busy at home. Wyckoff reminded her readers that modern inventions had changed the way everyone spent their time, not just children. Before long, a group of residents organized a board, and a corporation was formed called the Associated Boys Clubs of Locust Valley.

PREVENTATIVE MEASURES. Amid the overall optimism of the day, newspapers across the country reported on the growing incidents of "juvenile delinquency." Although the crime rate in Locust Valley was never high, local citizens shared this national concern. While schools, homes, and churches provided the ultimate bulwark against criminal mischief and other bad behavior, a boys club was seen as the final link in guiding youth toward good citizenship.

MILWARD "PIDGE" MARTIN. Martin convinced fellow board members that Locust Valley would benefit from an independently run club under the aegis of Boys Clubs of America with the help of Pepsi-Cola chairman Walter Mack. Martin played a pivotal role in the founding of the club and served as secretary of its board of directors until 1969, when he became chairman of the board of overseers.

SHERMAN PRATT. Cofounder Pratt became the club's president for its first 17 years until his death in 1964. Upon his passing, Martin described Pratt as a "whole" man imbued with great "humility and gentleness." Pratt believed that children needed "a special place" to thrive and did everything in his power to make this possible. He gave generously of his lands, his fortune, and of himself as well.

Club's Historical Record, 1947. In addition to providing an advisory service for designing the clubhouse and future additions, the national organization provided a wealth of training for staff and accredited programming for the members. The club's leadership particularly valued the emphasis on preparing board members for the important task of responsible governance needed to grow and maintain a successful club.

INFORMATION ABOUT YOUR BOYS' CLUB

It is important that board members be informed regarding the organization they are serving. Information concerning the history, organizational structure, financial status, membership and operational policies of the Club should be furnished to all board members.

It is suggested that Boys' Clubs reproduce and use the following form for this purpose:

HISTORICAL RECORD

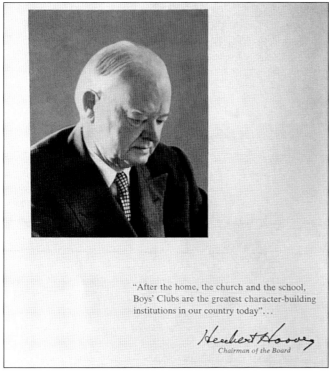

"After the home, the church and the school, Boys' Clubs are the greatest character-building institutions in our country today"...

Herbert Hoover
Chairman of the Board

Former President Herbert Hoover. As an orphan himself, Hoover appreciated the Boys Clubs of America's mission "to enable all young people, especially those who need us most, to reach their full potential as productive, caring and responsible citizens." During Hoover's tenure as chairman, membership doubled from 300 clubs in 1936 to 600 clubs in 1960. Each year during Hoover's life, Boys Clubs across America celebrated his birthday.

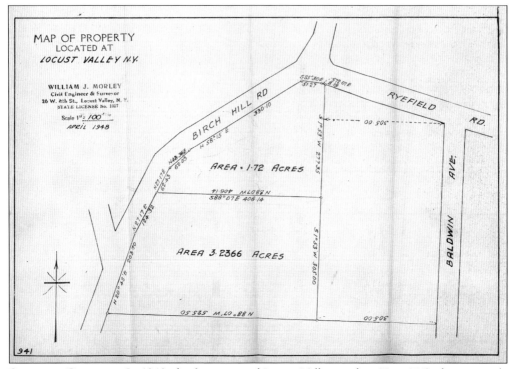

DICKINSON DONATION. In 1948, the financier and Locust Valley resident Hunt T. Dickinson made the first big donation to the club of six acres in Lattingtown. Despite its not being a feasible site for the clubhouse, Dickinson generously gave permission for the club to sell the land to finance the completion of the building on Forest Avenue. He added an additional acre in 1949 when an adjoining parcel became available.

LEADER ANNOUNCES BAKER GIFT. In 1949, Edith Baker made a gift of $31,500 for a clubhouse and two acres on Forest Avenue in memory of her son Grenville. Owned by the estate of William Guthrie, the vacant property had been used as a ball field by locals. The design for the clubhouse was donated by architect Bradley Delehanty. Soon, plans were underway to hire a full-time supervisor for the club.

CLUB HIRES WILLIAM HINCKLEY.
When Hinckley began his job in 1949 as the first executive director of the club, he was 26 years old, married, and the father of two small boys. The Idaho native was a graduate of George Washington University and a World War II veteran. After the war, he became involved in Boys Clubs of America and worked as the assistant director of the Boys Club of Washington, DC.

MARY MARTIN. The wife of Pidge Martin, Mary became a devoted supporter of the club from the outset. At the first June dance hosted at the Pratts' home, she and Ethel Pratt were a great team. Along with cochairing the June dance, she joined the club's board of overseers from 1975 until her death at age 100 in 1999. (Courtesy of Sarah Fletcher.)

Associated Boys' Clubs
of
Locust Valley, Inc.

invites you
to the dedication of

Grenville Baker Club House
135 FOREST AVENUE LOCUST VALLEY, N. Y.

Sunday afternoon, Nov. 5, 1950

PROGRAM

Dedication Ceremonies, 3 p. m.

The Club House and playing field will be open for your inspection beginning at 2:30 p. m.

INVITATION TO DEDICATION. Hundreds attended the dedication ceremony on Sunday, November 5, 1950. The ceremony opened with a tour of the clubhouse and a selection by the school band. Club president Sherman Pratt greeted the guests, reading several telegrams from well-wishers, including Herbert Hoover. After the invocation, club secretary Pidge Martin spoke of the club's origins and the late Grenville Baker, in whose memory the club was erected.

WORDS OF THANKS. Standing with Sherman Pratt, Edith Baker described how Grenville Baker considered Locust Valley his home, making the club a fitting tribute to her son. After a prayer of dedication, board member Newton Millham acknowledged builder James Robertson and architect Bradley Delehanty as well as several important donors who made the project a success.

GRENVILLE KANE BAKER, 1921–1949. Baker grew up in Locust Valley and attended St. Paul's School, New Hampshire, and Harvard University. In 1942, he enlisted in the Army Air Corps. He successfully completed flight training and, in June 1944, was assigned as copilot with a replacement aircrew in the 713th Squadron of the 448th Bombardment Group, 8th Army Air Corps, headquartered in England. Their mission was to conduct daylight bombing raids on strategic German targets, including weapons factories, refineries, and railroad yards. These sites were heavily defended by antiaircraft guns on the ground, Luftwaffe in the air, and radar that let the Germans know when the American planes were coming; according to military historians, these missions were some of the most hazardous assignments of the war. After returning from the service in 1948, he tragically died months later at the family plantation in Florida.

AIR MEDAL DECORATION

BAKER, GRENVILLE K. (0-819192), 2nd Lieut. A. C.
 GO #119, Hq. 2nd Bombardment Division, 7-6-44
OAK LEAF CLUSTERS AWARDED BY 2ND BOMBARDMENT DIV.:
1 - GO #152, 7-26-44
1 - GO #185, 8-12-44
1 -,GO #210, 8-30-44
1 - GO #302, 11-14-44

New York, N.Y.

BAKER'S AIR MEDAL DECORATION RECORD. As a second lieutenant in 1944, Baker was awarded the Air Medal with four Oak Leaf Clusters for his 35-plus combat flight missions. Later in 1944, he was promoted to first lieutenant and was awarded the Distinguished Flying Cross. After completing his combat mission requirements, Baker was assigned to Gen. Frederick Anderson, flying him in his B-17 over Europe and back and forth across the Atlantic Ocean. He was discharged from active duty after the end of the war, having attained the rank of captain.

RAISING THE FLAG. The flagpole and base in front of the club were a gift from Locust Valley's American Legion Howard Van Wagner Post 962. The club, with its healthy activities and training, was seen as a positive guide for boys toward patriotism and good citizenship, joining local schools, families, and churches in achieving this goal.

NEW MEMBERS. Drawn by the beautiful new clubhouse and programming, young boys flocked to the club. Registration was limited to boys ages 8 to 17. Annual membership cost $1 for midgets ages 8 through 10, $2 for juniors ages 11 through 13, and $3 for intermediates ages 14 through 16. Hours were weekdays, 3:30 p.m. until 9:00 p.m., and Saturday, 9:00 a.m. until 3:00 p.m.

DOG AND BICYCLES. After school in the 1950s, most members walked to the club. Some rode bikes. Bicycles were a prized method of transportation not available to all. In 1950, actor William Boyd, also known as Hopalong Cassidy, sent the club two new bicycles. The next year, they were given as prizes to Jerry Nelson, 11, and David Brown, 10, for selling the most tickets to the June dance.

Mr. and Mrs. Sherman Pratt

request the pleasure of your company

at the Tenth Anniversary Ball of

The Grenville Baker Boys' Club

on Saturday, the twenty-seventh of June

Nineteen hundred and fifty-nine

at eleven o'clock

"Still Pond"

Horse Hollow Road

Locust Valley, Long Island

STILL POND. Before the clubhouse had been completed and dedicated, Sherman and Ethel Pratt hosted a dance in June 1950 to raise much-needed funds. Held at their home, Still Pond, attendance was "limited" to 500 guests and was quickly oversubscribed. They repeated their success by hosting the 10th-anniversary dance.

FAITHFUL STEWARDS. From left to right, Edith Baker, Ethel Pratt, and Mary Patricia Doubleday served as longtime members of the club's board of overseers and on the annual June dance committee. When the club expanded in 1955 to include a gymnasium and in 1959 to landscape the Cushing Memorial Fields, the George F. Baker Trust and special gifts from Baker's friends again helped to make it possible.

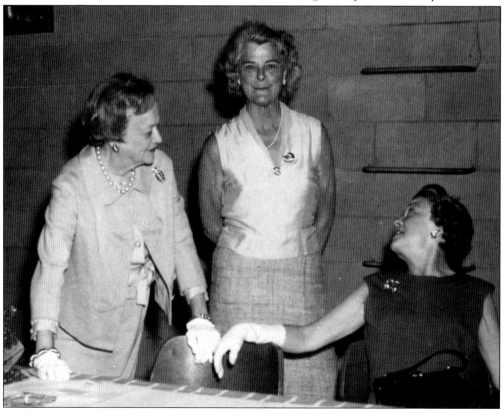

BEHIND THE SCENES. Various committees worked tirelessly to plan the 1967 June dance held at Meadow Spring, the Duck Pond Road home of John and Jane Allen. In the journal, men's committee chair R. Stuyvesant Pierrpont Jr. noted the turbulent times and exhorted donors to consider tomorrow when donating to the Boys Club today and give more.

HAWK HILL PLACE. The 1951 June dance was held at Hawk Hill Place in Lattingtown, the former home of Grace Stehli and the late Henry Stehli. Designed by Treanor & Fatio, the 30-room Colonial Revival home was built in 1923 and expanded with large formal entertaining rooms in 1929. Maurice Fatio would go on to become one of the leading architects of Palm Beach. (Courtesy of Paul J. Mateyunas.)

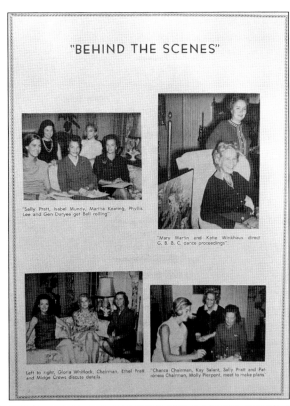

"BEHIND THE SCENES"

"Sally Pratt, Isabel Mundy, Martha Kearing, Phyllis Lee and Gen Duryee get Ball rolling".

"Mary Martin and Katie Winkhaus direct G. B. B. C. dance proceedings".

Left to right, Gloria Whitlock, Chairman, Ethel Pratt and Midge Crews discuss details.

"Chance Chairman, Kay Salant, Sally Pratt and Patroness Chairman, Molly Pierpont, meet to make plans".

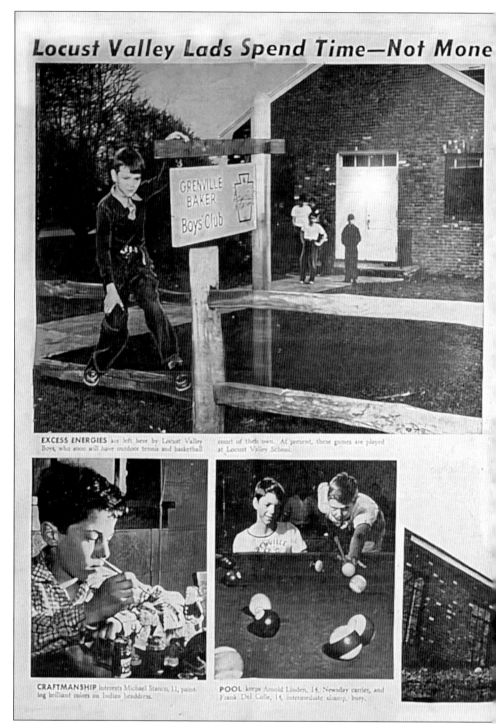

Locust Valley Lads Spend Time—Not Mone

EXCESS ENERGIES are left here by Locust Valley Boys, who soon will have outdoor tennis and basketball court of their own. At present, these games are played at Locust Valley School.

CRAFTMANSHIP interests Michael Stancu, 11, painting brilliant colors on Indian headdress.

POOL keeps Arnold Linden, 14, Newsday carrier, and Frank Del Colle, 14, intermediate champ, busy.

LONG ISLAND NEWSDAY, 1952. The club drew the attention not just of the *Locust Valley Leader*, but of the *Long Island Newsday* as well. Boys Clubs of America was also curious to see if a club would succeed in Locust Valley and set an example for other small communities around the country. Concern over the spread of juvenile delinquency in the 1950s was widespread, not only

h Grenville Baker Boys Club

(Newsday Photos by Maguire)

Locust Valley who are lives at a minimum cost the Grenville Baker Boys by residents of the area, a young local war hero from the front but died in at in Florida. Its leader formerly of Washington, ania, where he organized th to tremendous vitality The members are divided with the youngest paying boys, $3 per year dues are given odd jobs to earn the club owns its $30,000 grounds. Below, Stanley approve his 75 club cham-

QUARTERMASTER Ronald Hinckley hands equipment to Harry Bigby, 14

NOT FAR FROM BOYHOOD himself, and with two boys of his own, Bill Hinckley fits the part of director. Sons Scott, 3, and Ronald, 6, think so, too.

Newsday

among the less affluent, but across the spectrum. There was also some skepticism about who would benefit from the club and whether they would appreciate it. Viewing it as an important investment in the future of their town, Locust Valley accepted the challenge and deemed it an investment worth making.

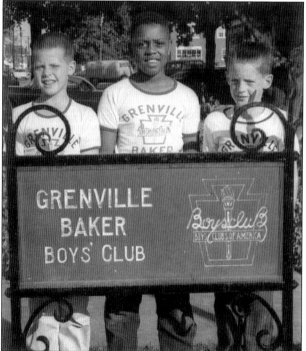

DEDICATED TEAM, 1952. Sherman Pratt and Edith Wyckoff continued to work hard in their respective roles to ensure the club's success. When expenses ran over the first two years, Pratt made up the deficit to accommodate the growing number of boys who wanted to join. To Pratt, "when you have a bear by the tail you have to go with the bear and that is what we did."

A PART OF HISTORY. From left to right, Rob MacDonald, Elliott Garrison, and Jimmy Eliseo proudly show off the Boys Club's newly minted sign. The creation of Grenville Baker Boys Club and its robust history and growth were testaments to the Locust Valley community and to the notion that the whole is greater than the sum of its parts.

Two

ATHLETICS

From the beginning, the founders of Grenville Baker Boys Club understood the importance of athletics to the organization and its mission. In addition to the tangible benefits of physical fitness, sports provided the invaluable lessons of teamwork and dedication. Moreover, athletic competition established a democratic meritocracy for local boys of all socioeconomic backgrounds that set the tone for the club for years to come.

The fervent wish of the club's original members was to have a place to play sports, with organized games, practices, coaches, referees, and uniforms. From the beginning, the boys were able to play football behind the club, even if the grounds were rough and uneven in places. However, with no gymnasium of its own, the club had to find other places for basketball, often scheduling games at the local school or in other towns. The club accepted invitations to tournaments as far away as Washington, DC, and Pennsylvania. Not only did such trips provide a venue for basketball, but they also afforded the boys an opportunity to see new places. Those members who had yet to venture beyond Locust Valley enjoyed traveling with their teammates and friends.

Eventually, as the club's membership grew, so did the arguments in favor of adding a new gymnasium to the clubhouse. Scheduling travel was not always an option and using the Locust Valley school gym when available was far from ideal. Not only did the school need the gym for its own students and other community groups, going outside the club caused transportation problems and divided the club staff needed to supervise the boys in both places. Playing basketball at the school also kept members from segueing after games and practice to other programs at the club.

With that in mind, a gymnasium addition was proposed and constructed in 1956, uniting athletics and other programs under one roof. Three years later, the board raised the funds to improve the athletic fields behind the club as well. The team spirit, friendships, and cohesiveness developed on those fields and reinforced in the clubhouse proved to be the ultimate reward.

IMPORTANCE OF ATHLETICS. In 1949, the club's board of directors wrote a letter to the *Leader* stating: "Locust Valley boys are the equal of American boys everywhere at any time, with all the promise of usefulness and greatness that American boys have always shown. That promise flowers best, we believe, in the atmosphere of fine, competitive athletics, properly supervised, and to give them that in this community is our purpose."

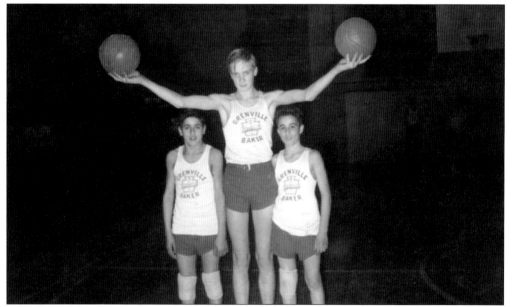

SPORTS FOR ALL AGES. Beginning in the club's first year, intramural basketball players were divided into Pee Wee, ages seven to nine; Biddy, ages 10–12; and Little Pro, ages 13–15. Biddy All-Stars played against other teams across Long Island. Baseball players were divided into three intramural levels: Minor League for ages seven to nine, Major League for ages 10–12, and International League for ages 13–15.

INVITATIONAL TOURNAMENT. In 1950, Hinckley organized a basketball tournament for the Christmas holiday week to be played at the Locust Valley School gym. The entry fee for each team was $5 and included team trophies and individual player awards. Teams came from Oyster Bay, Hicksville, Glen Cove, New York City, and New Jersey. This led to reciprocal invitations for Grenville Baker boys to play at other clubs.

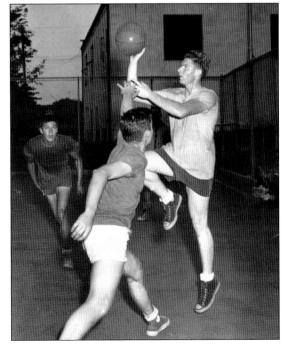

PICKUP GAMES ON THE OUTDOOR COURT. In May 1953, a lighted, hard-surface, multiuse play area with a basketball court was built and dedicated alongside the clubhouse. This was one of many things financed at the club by the sale of the Dickinson land gift. The welcome addition was put to immediate use for basketball, ball hockey, and other games.

GOLF TEAM. In 1954, Grenville Baker boys played golf at the Nassau Country Club with equipment donated by Sherman Pratt and others and hosted a tournament inviting foursomes from New York City and Mount Vernon Boys Clubs. In August, the Bethlehem Boys Club of Pennsylvania came to play a return match at the Creek Club. That summer, the boys also entered and won ribbons at a putting contest at a Nassau County park.

NEED FOR NEW GYMNASIUM. By 1955, the number of boys who wanted to join the club had grown beyond expectations. In 1950, there were 192 members. By 1955, the enrollment was up to 263, with numerous applications being turned away. The board estimated there were 732 boys in the district of age. The club wanted to welcome them all but did not have enough room to serve them.

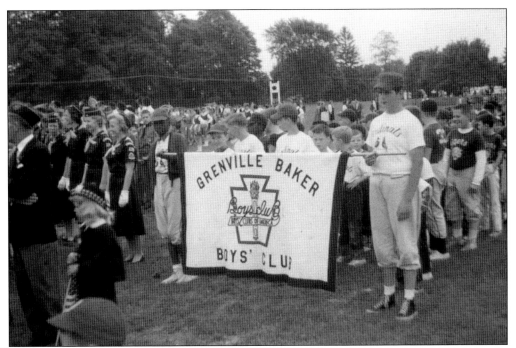

PARADES. Each year, the club marched with other local organizations in the Memorial Day parade. In 1955, the boys also marched in a second, smaller parade to celebrate Boys Club Day with two fire trucks, the school band, and both Boy and Girl Scout troops. Club members spent the rest of the day conducting a door-to-door canvas asking residents to "give till it helps" to finance the new gymnasium expansion.

PLANS FOR EXPANSION. Under the careful supervision of board president Sherman Pratt, the club sought to maximize the use of the new space by adding a gymnasium on the first floor and two club rooms, a library, an older boys' games room, a shooting gallery, a kitchen, showers and dressing room, and additional storage space in the basement.

THE LOCUST VALLEY BOY'S CLUB
LONG ISLAND · NEW YORK

ARCHITECT ALFRED SHAKNIS. Having designed the Roslyn Savings Bank, Brookville Police Station, and the C.W. Post Library as well as several country estates along the north shore, Shaknis was chosen by the board for his proven ability to combine utility and elegance in his designs. The board was confident Shaknis's plan would complement Delehanty's original brick clubhouse while creating a welcome addition to Locust Valley's town center.

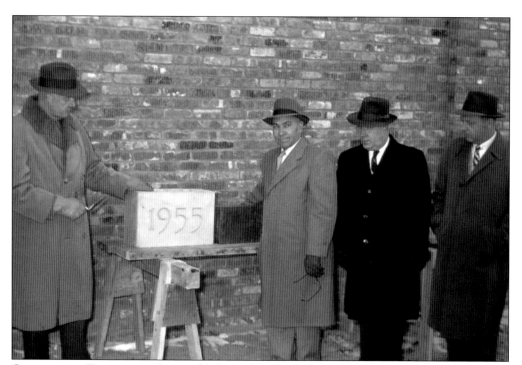

CORNERSTONE DEDICATION. On a cold day in late December 1955, the cornerstone of the new gymnasium was laid and dedicated by, from left to right, board president Sherman Pratt, builder Samuel Carucci, board secretary Milward "Pidge" Martin, and general contractor Roy Falconer. By May the following year, the club celebrated the completion of the $190,679 construction project.

MORE SPACE, MORE SPORTS.
William Cullum, shown above with the boys, served as assistant director from 1952 before moving to Florida in 1959. With the new gymnasium in 1956, the club added boxing, wrestling, and fencing for boys of all ages in addition to the basketball and volleyball leagues. By 1958, the wrestling program offered on Wednesday afternoons was overseen by Dr. Robert Vorisek, who had wrestled during his college years at Michigan State. Several boys from the club who attended the program went on to wrestle in college. On Friday afternoons, aspiring boxers like Scott Hinckley participated in the boxing program started by Hank Roberts, a golden gloves boxer from Locust Valley, with an annual boxing exhibition in the winter.

REUNION HOSTED. In 1957, the alumni of Locust Valley's legendary Yellow Jackets football team gathered at the club. Founded in 1927, the semipro team won the Long Island Championship in its second year. During the Yellow Jackets' six-year run, the organization won more than fifty games and lost only eight. Twenty-four alumni attended the reunion, enjoying old stories and watching Grenville Baker's midget varsity team defeat Syosset, 21-0.

CLUB FIELDS. Before the club, the overgrown expanse at the corner of Weir Lane and Elm Street, full of briars, brambles, and brush, was lovingly known to local boys as "Rats Stadium" because of the many field mice who called it home. With the success and popularity of the club's athletic programs, the acres (and mice) had been cleared out and bleachers added.

CUSHING MEMORIAL ATHLETIC FIELDS. By 1959, the fields badly needed to be regraded, reseeded, and re-fenced. Men's Club member James MacDonald Sr. directed the project, landscaping the athletic fields behind the clubhouse. Baseball backstops were also installed. The fields were dedicated to Edith Baker's dear friend, the late Charles G. Cushing, and funded by the generous donations of his friends, including his golfing partner, the Duke of Windsor.

E.C. "WOODY" LEWIS. Raised in upstate New York, Lewis earned a degree in physical education at Siena College and received training from Boys Clubs of America at New York University. Prior to the club, his work experience included the Rotterdam Boys Club in Schenectady, New York, and the School for the Deaf in Mill Neck, New York. In 1959, he became the club's athletic director and then the executive director from 1962 to 1989.

LONG ISLAND CHAMPIONS, 1959. The undefeated midget team included (first row) coaches Brian Hahn and Woody Lewis; (second row) Charles Soper, John Kelczewski, Ralph Eliseo, Jim MacDonald, Scott Hinckley, and Frank Pavone; (third row) Russ Hvolbek, Tom Moseley, Norman Curth, Louis Sanford, Kenneth Vorisek, and Edwin Birkins; (fourth row) Tom Colgrove, Mark Grier, Michael Lawless, Billy Johnson, and David Bambey; (fifth row) George Gregory, Steve Frontz, Sandy Barclay, Tom Vorisek, Ronald Hinckley, and Newton Millham.

MIKE "TREE" GIBSON. Gibson first joined the club in 1954 at seven years old. An exceptional athlete, he went on to play baseball, football, and basketball there. When Gibson graduated from college in 1969, executive director Woody Lewis invited him to become the club's assistant athletic director and then, in 1972, the athletic director. For almost 50 years, Gibson continued to supervise and referee all sports at the club.

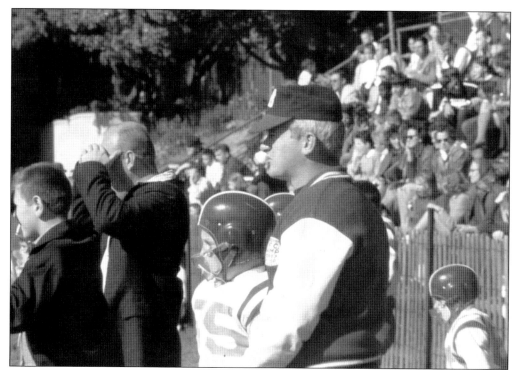

BRIAN HAHN. A charter member in 1950, Hahn played in the club's early football scrimmages against Friends Academy. As an adult, he coached football and other sports at the club. His dedication reached legendary status in 1959 when he returned a day early from his honeymoon to help coach an important football game. Always helpful, Hahn also occasionally covered at the front desk when needed.

TRAVEL AND INTRAMURAL FOOTBALL. By 1960, more than 150 boys participated in the club's football program. In addition to the midget varsity travel team for boys ages 12 to 14, in the seventh and eighth grades and weighing no more than 170 pounds, the club added two intramural leagues: the Little Ivy League, which included boys ages 8 to 10, and the Big Ivy League, with boys ages 13 to 15.

THINK YOUNG–

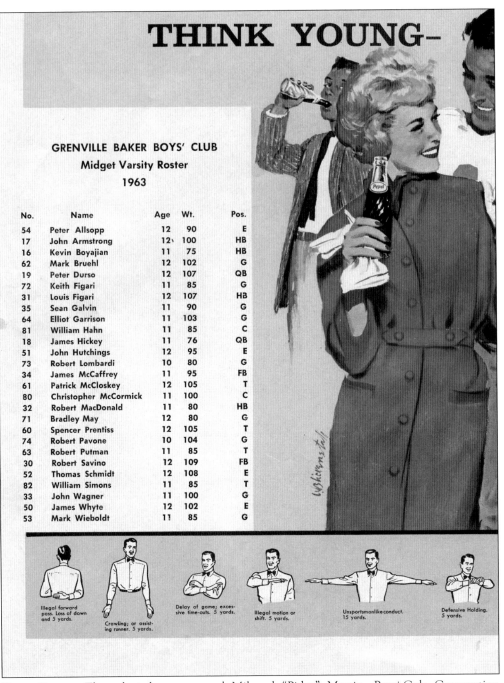

GRENVILLE BAKER BOYS' CLUB
Midget Varsity Roster
1963

No.	Name	Age	Wt.	Pos.
54	Peter Allsopp	12	90	E
17	John Armstrong	12	100	HB
16	Kevin Boyajian	11	75	HB
62	Mark Bruehl	12	102	G
19	Peter Durso	12	107	QB
72	Keith Figari	11	85	G
31	Louis Figari	12	107	HB
35	Sean Galvin	11	90	G
64	Elliot Garrison	11	103	G
81	William Hahn	11	85	C
18	James Hickey	11	76	QB
51	John Hutchings	12	95	E
73	Robert Lombardi	10	80	G
34	James McCaffrey	11	95	FB
61	Patrick McCloskey	12	105	T
80	Christopher McCormick	11	100	C
32	Robert MacDonald	11	80	HB
71	Bradley May	12	80	G
60	Spencer Prentiss	12	105	T
74	Robert Pavone	10	104	G
63	Robert Putman	11	85	T
30	Robert Savino	12	109	FB
52	Thomas Schmidt	12	108	E
82	William Simons	11	85	T
33	John Wagner	11	100	G
50	James Whyte	12	102	E
53	Mark Wieboldt	11	85	G

Illegal forward poss. Loss of down and 5 yards.

Crawling; or assisting runner. 5 yards.

Delay of game; excessive time-outs. 5 yards.

Illegal motion or shift. 5 yards.

Unsportsmanlike conduct. 15 yards.

Defensive Holding. 5 yards.

PEPSI, PLEASE. Through in-house counsel Milward "Pidge" Martin, Pepsi-Cola Corporation remained a loyal supporter of Grenville Baker Boys Club and the main sponsor of the club's glossy football brochure. In addition to an illustrated guide to referee signals, the brochure provided important information on the team rosters and game schedules, both intramural and varsity.

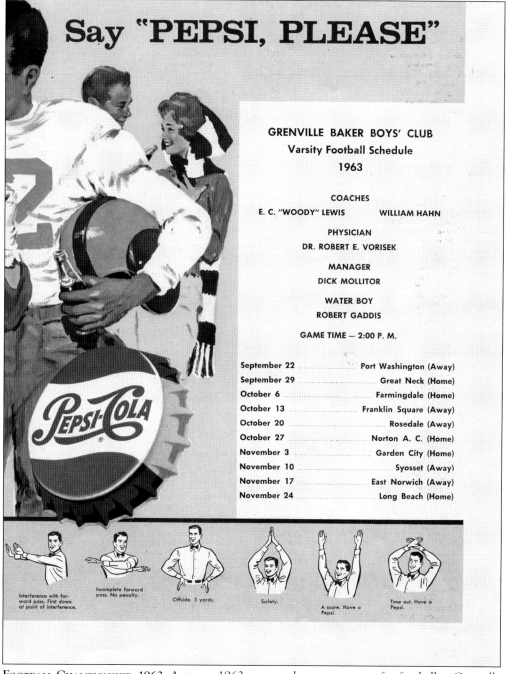

FOOTBALL CHAMPIONSHIP, 1963. Autumn 1963 was another great season for football at Grenville Baker. The midget varsity team won Long Island's Division II football league championship when they defeated Great Neck 40-0. The stars of the game were John Hutchings, Louis Figari, Pete Durso, and Tommy Schmidt. In league play across Long Island, the team ended the season with a perfect record, with eight wins and zero losses.

MATT SNELL. One of the greatest athletes to have played at the club was Super Bowl champion and New York Jet Matt Snell. The Snell family moved to Locust Valley in 1950 when he was nine years old. Two years later, he joined the club and played sports. Snell credited the club with providing a safe place after school and for keeping him out of trouble during his early teen years. In ninth grade, Snell attended Carle Place High School, where he became a high school All-American in football. At Ohio State, he was named cocaptain and MVP his senior year and played multiple positions as defensive end and offensive halfback and fullback. In 1964, the Jets selected Snell in the first round, and he was named the American Football Conference Rookie of the Year. That year, 150 boys and staff from the club traveled to the Jets Peekskill facility as his guests to watch a team practice. Snell went on to score the Jets only touchdown in their history-making victory in Super Bowl III.

Three

CAMPS

As membership grew, club leadership organized summer activities to keep boys busy and active when school was out. The goal was to encourage the boys' sense of responsibility along with their sense of adventure. By the mid-1950s, the club had a range of summer camp options for their members to enjoy.

Locally, younger boys attended Camp Small Fry at the clubhouse and the nearby Pratt estate. The campers participated in swimming, riflery and archery, fishing, and other waterfront activities. The day began and ended with a show of patriotism, raising and lowering the flag, and singing the national anthem. A variety of day trips were added to New York City, including to the Museum of Natural History, the Bronx Zoo, and a boat trip around Manhattan. Closer to home, the boys hiked through Shu Swamp in Mill Neck and toured the Fish Hatchery in Cold Spring Harbor and Theodore Roosevelt's home at Sagamore Hill in Cove Neck. For several years, Rye Playland in Westchester, New York, was a favorite destination. Overnight camping trips and sleepaway camps were also added in Pennsylvania, Massachusetts, and upstate New York.

In 1955, through the further generosity of club president Sherman Pratt, a dozen teenage members visited the wilds of New Brunswick, Canada, and the beloved Canadian Camp began. The Pratt family held the fishing rights to a large tract of land on Holmes Lake, where they built a cluster of log cabins with two dormitories, a director's cabin, a dayroom cabin, and a multipurpose building that included a kitchen, cook's quarters, and dining area.

To gain the privilege of attending Canadian Camp, boys earned community service points throughout the school year. Once there, they were responsible for their own laundry as well as helping with meal preparation, campground maintenance, trail clearing, and other duties. From 1955 until 1976, each summer, boys learned essential camping skills while enjoying a month of swimming, fishing, waterskiing, and hiking, creating lifelong memories and friendships. Alumni look back on those days at Canadian Camp and cite its positive, long-lasting impact on their lives.

CAMP SMALL FRY. In 1957, the club provided its first full summer of day camp for nine weeks during July and August, Monday through Friday, for boys aged seven to eleven. The cost was $7.50 per week for each child. Camp activities included swimming, arts and crafts, nature study, hiking, field trips, and a weekly opportunity for overnight camping.

ARCHERY, RIFLERY, AND GAMES. On the fields and in the clubhouse, the Small Fry campers played sports, including basketball, softball, and Wiffle ball, as well as all kinds of games, both indoors and out. They competed in archery and riflery, perfecting their skills and hoping to win camper of the week.

TRANSPORTATION. In addition to the clubhouse and fields on Forest Avenue, the Small Fry activities often took the boys to Pratt's woods on Sheep Lane and Stehli's Beach in Bayville as well as other destinations nearby. When the club's bus was not available, carpools were organized with boys piling into parents' cars or the club station wagon donated by Sherman Pratt.

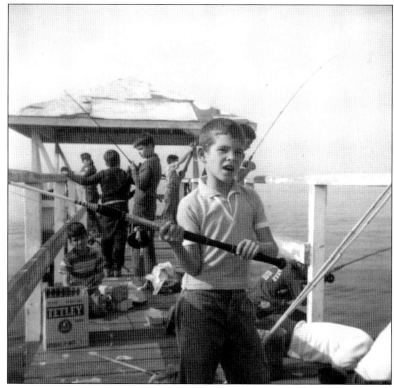

FISHING. Learning about the joy of fishing was a big part of summer camp. With the Long Island Sound only a couple miles away from the clubhouse, it was a natural destination for the Small Fry campers. The best part about a day of fishing was the stories shared once the day was done.

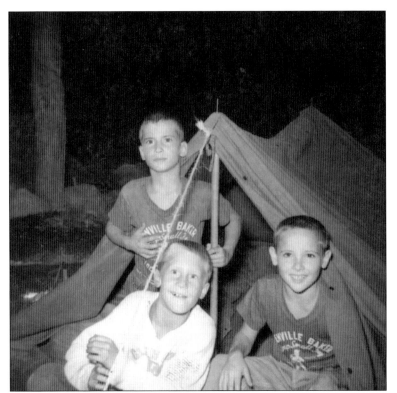

CAMPING OUT. The boys learned camping techniques at the Pratt's woods campsite. On Thursdays, the boys set up their camp, erecting pup tents, gathering firewood, and preparing latrines. They planned the menus and helped prepare the meals. At night they held their own council circle, with funny skits, songs, and storytelling.

STEHLI'S BEACH, BAYVILLE. Friday mornings were spent cleaning up the campsite, taking down tents, and stowing camping gear for future use. Once their work was done, the boys could hike and enjoy Pratt's woods. In the afternoon, they walked a quarter mile east along Fox Point to Stehli's Beach for relaxation, games, and a swim in the Long Island Sound.

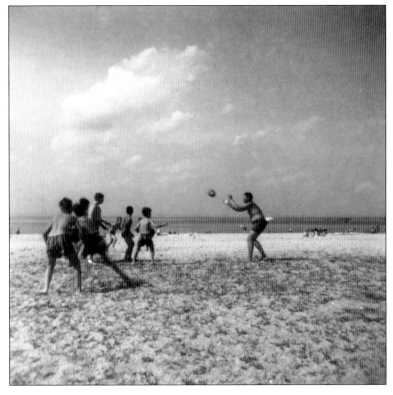

OTHER DESTINATIONS. In addition to overnight camping in Pratt's woods, the Small Frys took camping trips farther afield in New York State. Over the years, their trips included Montauk Point, Lake George, Bear Mountain, and Hunter Mountain. In 1971, a group from the club toured the battlefields of Gettysburg, Pennsylvania, and camped out in MacMillan Woods, the mustering area for the famous Pickett's Charge.

SLEEPAWAY CAMPS. By the summer of 1960, six hundred boys enjoyed a variety of summer camping experiences through the club, including sleepaway camps. Older members of Camp Small Fry enjoyed Camp Mohican near Bethlehem, Pennsylvania, as well as Broad Horizons Ranch in Muncy Valley, Pennsylvania; Camp Rainbow in Duchess County, New York; and Camp Lovejoy in Altamont, New York.

DELAWARE WATER GAP. Camp Mohican was a two-week residence camp run by the Boys Club of Bethlehem, Pennsylvania, near the New Jersey and Pennsylvania border. Located at the Delaware Water Gap, the camp was known for its beautiful vistas, hiking, and water activities. The boys enjoyed fishing, boating, and swimming on the river in addition to exploring, overnights, and cookouts in the nearby mountains. Also included were campfires, athletic activities, and the enjoyment of some fine Pennsylvania Dutch cooking. At the camp's rifle range, boys received instruction in riflery and were able to practice shooting. In August 1957, the group of campers from the club had an exciting experience when rising floodwaters forced an evacuation of the camp. Although the boys were not in danger, conditions were challenging, and they were glad to arrive home safely.

CANADIAN CAMP ACCEPTANCE LETTER. Through service, older club members won the opportunity to attend Canadian Camp, competing to earn the most points in seven major categories: school, church, Boys Club, Boy Scouts, community improvement, camping skills, and general attitude and behavior. The contest began in January, and acceptance letters were received in June. Locust Valley's Rotary and Women's Clubs provided "camperships" for boys who could not afford the camp fees.

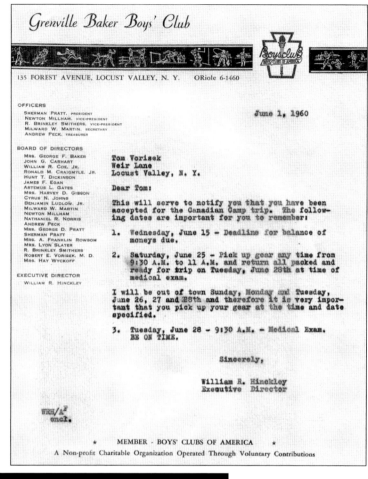

Grenville Baker Boys' Club

135 FOREST AVENUE, LOCUST VALLEY, N. Y. ORiole 6-1460

June 1, 1960

OFFICERS
SHERMAN PRATT, PRESIDENT
NEWTON MILLHAM, VICE-PRESIDENT
R. BRINKLEY SMITHERS, VICE-PRESIDENT
MILWARD W. MARTIN, SECRETARY
ANDREW PECK, TREASURER

BOARD OF DIRECTORS
MRS. GEORGE F. BAKER
JOHN G. CARHART
WILLIAM R. COE, JR.
RONALD M. CRAIGMYLE, JR.
HUNT T. DICKINSON
JAMES F. EGAN
ARTEMUS L. GATES
MRS. HARVEY D. GIBSON
CYRUS N. JOHNS
BENJAMIN LUDLOW, JR.
MILWARD W. MARTIN
NEWTON MILLHAM
NATHANIEL R. NORRIS
ANDREW PECK
MRS. GEORGE D. PRATT
SHERMAN PRATT
MRS. A. FRANKLIN ROWSOM
MRS. LYON SLATER
R. BRINKLEY SMITHERS
ROBERT E. VORISEK, M. D.
MRS. HAY WYCKOFF

EXECUTIVE DIRECTOR
WILLIAM R. HINCKLEY

Tom Vorisek
Weir Lane
Locust Valley, N. Y.

Dear Tom:

This will serve to notify you that you have been accepted for the Canadian Camp trip. The following dates are important for you to remember:

1. Wednesday, June 15 - Deadline for balance of moneys due.

2. Saturday, June 25 - Pick up gear any time from 9:30 A.M. to 11 A.M. and return all packed and ready for trip on Tuesday, June 28th at time of medical exam.

I will be out of town Sunday, Monday and Tuesday, June 26, 27 and 28th and therefore it is very important that you pick up your gear at the time and date specified.

3. Tuesday, June 28 - 9:30 A.M. - Medical Exam. BE ON TIME.

Sincerely,

William R. Hinckley
Executive Director

WRH/A²
encl.

★ MEMBER · BOYS' CLUBS OF AMERICA ★
A Non-profit Charitable Organization Operated Through Voluntary Contributions

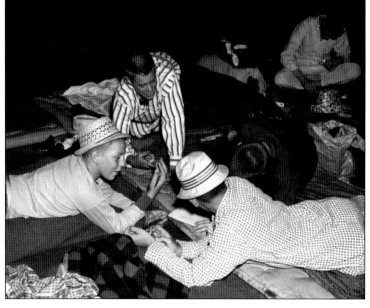

JOURNEY TO NEW BRUNSWICK. The three-day bus trip up to Holmes Lake, New Brunswick, Canada included an overnight stopover in Waterville, Maine. Accommodations were provided by Waterville's Boys Club in their gymnasium. Campers in their pajamas are, from left to right, Thomas Vorisek, Russell Hvolbek, Sandy Barclay, and Jerry Dykstra in 1961.

TRANSPORTATION TO CANADA. During the first years of Canadian Camp, the boys were packed into two cars for the trip. In 1961, when Long Island's Mitchel Air Force Base was decommissioned, the club was given an old army surplus bus. Local supporters helped finance its reconditioning for the trip north. At Holmes Lake that July, campers and staff are, from left to right (first row, sitting) Randy Waskawic, Dick Faber, Canadian Scouts Kenneth Connell and Richard McIvor, Russell Hvolbek, Joseph Durso Jr., and Stephen Piro; (second row, kneeling) Kenneth Martin, Ross Edwards, unidentified, Sandy Barclay, William Posch, David Bambey, Jonesy Nollman, Andy Johnson, Kenneth Deecken, Bob Mollitor, Frank Giovinazzo, Ronald Hinckley, Frank Schmid, John Jordon, Tony Millham and Thomas Vorisek; (third row, standing) Dominick Giovinazzo, Andy Semansco, L.T. Henniger, William Hinckley, and Newcastle deputy sheriff Kiah Copp.

MAIN BUILDING CANADIAN CAMP

MAIN BUILDING. The main building of the Pratt family's "Winter Camp" was central to the Boys Club's Canadian Camp. Located at Holmes Lake on the Southwest Miramichi River, the rustic nature of the facilities, the pristine forests, and outstanding fishing provided a unique setting. Each day, the boys received instruction in woodcraft, camping, and canoeing as well as tree, plant, bird, and animal identification.

WELCOME TO HOLMES LAKE. On arrival, the boys were divided into three groups. One group remained at the main camp, and the other two went to camp in the woods for three or four days. A cook fed the boys at the base. Those on the outward trek went on a hiking and canoe trip, acting as their own chefs.

47

WAKE-UP CALL. During the warmer weather, some of the boys preferred the tents to the stuffy cabin. While campers were expected to rise early on their own, William Hinckley occasionally helped. The logistics of managing boys, supplies, and staff was part of the challenge and the charm for their beloved camp director.

REV. JOHN DYKSTRA. Pastor to the Reformed Church of Locust Valley from 1954 to 1971, Dykstra was an active supporter of the club, lending his wisdom and insight where needed in Locust Valley and at Canadian Camp. Here, he is sharing his love of the great outdoors, leading a hike from the Winter Camp to Upper Forks in 1961.

CAMPERS, COUNSELORS, AND GUIDES. At the start of camp in 1961, a group photograph of campers, staff, and Canadian guides was taken. Wild game and smaller animals seen that summer included bears, deer, pine partridge, moose, caribou, fox, beaver, and muskrats, in addition to a large variety of birds. Each session, boys won awards for outstanding camper, top woodsman, fishing, riflery, archery, canoeing, waterskiing, swimming, hearts, and chowhound.

CANOES ON HOLMES LAKE. Upon arrival, every camper took a swim test to qualify for canoe privileges. From left to right are Ken Vorisek, Cliff Hinton, Steve Frontz, Jerry Dykstra, Eric Flower, Ralph Eyring, Steve Richbourg, Andy Young, Chip Clark, Woody Whyte, John Ruthkowski, Clyde Caldwell, Pat Pascucci, Walter Zaikowski, and Joe Durso Jr. rowing the 12-foot aluminum boat the club received in 1958 as an award for seamanship training.

NEW DINING HALL. This addition to the cook's cabin was built in 1957 by Nick Peters and John Dykstra with assistance from Hubert Holmes and Hiram Alison. In prior years, campers and staff ate their meals in shifts on small tables in the kitchen. The addition of the dining room was a major improvement for all.

MAKESHIFT BARBERSHOP. While the weather was variable in New Brunswick, it was often hot and muggy there in July and August. Although not required, crew cuts were recommended for campers considering the heat and the primitive bathing facilities. Most of the boys lined up for a trim by barber and senior counselor Rodman Pellett.

UPPER FORKS CABIN. One of nine remote camps to which the boys had access, this cabin was a three-mile hike through the woods followed by a one-mile canoe ride away from the main building. The experience of exploring and fishing in this true wilderness made it a favorite destination among the campers.

PINE TREE POOL. Another important landmark for some of the hardiest hikers at Canadian Camp, Pine Tree Pool marked the upstream limit of the Pratt family leasehold on the Southwest Miramichi River. After the long trek to get there, the challenge was to climb the overhanging limb of the tree to carve one's initials.

LOG BOOK. Made entirely of local birchbark, the Winter Camp log was created in 1957. Within its "pages" are inscribed the names of campers, counselors, guides, drivers, staff members, and visitors. Director Bill Hinckley and then Woody Lewis also recorded happenings that varied from weather mishaps, fishing stories, and minor injuries to winners of the Outstanding Camper Award. When this original camp log was full, a second one was begun in 1966.

CROSSING THE STREAM. The first groups of campers in 1955 were eager to hike and explore the vast woods and waterways around Holmes Lake. Here, the boys are seen walking in single file across a narrow footbridge at Smith Forks as they make their way over Cow Bay Stream where it joins the Little Southwest Miramichi River.

FISHING BUDDIES. Locust Valley physician Dr. Robert Vorisek (left) played many roles at the club and the camp, helping wherever he could and lending his experience in family medicine and his love of photography, wrestling, and birds. Shown here at the Upper Forks Cabin, he and William Hinckley (right) were both colleagues and lifelong friends who shared a love of fishing and Canadian Camp.

RODMAN PELLETT. Director of athletics at Friends Academy, Pellett became friends with Woody Lewis through coaching football in Locust Valley. Learning of Pellett's enthusiasm for the outdoors, skill with boats, and ability to coach young men, Lewis invited Pellett to join their team of senior counselors at Canadian Camp in 1960. He was fondly remembered for his attempt to invent a solar-heated shower, known as Pellett's Folly.

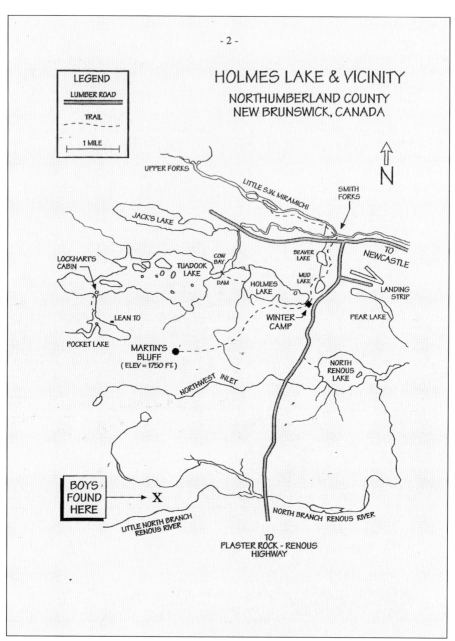

LEGEND

LUMBER ROAD

TRAIL

1 MILE

HOLMES LAKE & VICINITY
NORTHUMBERLAND COUNTY
NEW BRUNSWICK, CANADA

N

UPPER FORKS

LITTLE S.W. MIRAMICHI

SMITH FORKS

JACK'S LAKE

LOCKHART'S CABIN

COW BAY

TUADOOK LAKE

DAM

BEAVER LAKE

TO NEWCASTLE

MUD LAKE

HOLMES LAKE

LANDING STRIP

LEAN TO

WINTER CAMP

PEAR LAKE

POCKET LAKE

MARTIN'S BLUFF
(ELEV = 1750 FT.)

NORTH RENOUS LAKE

NORTHWEST INLET

BOYS FOUND HERE

X

LITTLE NORTH BRANCH RENOUS RIVER

NORTH BRANCH RENOUS RIVER

TO
PLASTER ROCK - RENOUS HIGHWAY

MAP OF HOLMES LAKE. On June 29, 1964, twenty-nine campers and three adults left Locust Valley for a month's stay at Canadian Camp. The boys looked forward to swimming, canoeing, fishing, sailing, waterskiing, and hiking. In addition to fun, the mission of the camp was "to teach the boys to have a sense of responsibility, to get along with others, to be able to do things for themselves and for others." That week, five of the boys set out for a Sunday afternoon hike to the tower at Martin's Bluff. The purpose of the hike was first to mark and clear the trail and then to experience the view from the tower. The boys reached their destination but got lost on their way back. When the boys failed to return for dinner on Sunday, a search was begun, including more than 100 volunteers and Royal Mounted Police. At first, rain made the search difficult. The boys were missing for three days and two nights.

LOST BOYS ARE FOUND. On Wednesday, the lost boys were found five miles from Holmes Lake and retrieved by helicopter. None of the boys suffered anything more than hunger and bug bites. They all stayed at camp until the end. Relieved but determined to prevent a repeat of the episode, Lewis planned to provide all future campers with survival instructions, rations, waterproof matches, first aid supplies, and a compass.

Five LI Boys Found Safe In Canadian Wilderness

By Mel Ray

Five Locust Valley, L.I., boys were found safe yesterday after being lost three days and nights in the swamps of a Canadian wilderness. But they don't intend to give up their month-long camping trip, and their parents don't want them to.

When a Royal Canadian Air Force helicopter plucked them from the edge of a swamp to end a massive search, the young hikers were wet, cold, hungry and fly-bitten. And their parents, who had worried and waited for 18 hours, had suffered, too.

The boys, members of the Grenville-Baker Boys Club, which has a camp at Holmes Lake 60 miles west of Newcastle, New Brunswick, are Thomas Schmidt, 13, of 113 Buckram Rd.; William Creighton, 14, of 31 West 4th St.; John Evans, 14, of Feeks Lane; Carmine Abate, 13, of 52 Underhill Ave.; and Kenneth Vorisek, 16, of 61 Weir Lane.

Camp officials said that the boys set out Sunday on a hike to an abandoned forest observation tower. They found the tower, but wandered off the trail returning to the camp. On Monday, more than 120 ground searchers started hunting for the youths in the bush area, one of Canada's most rugged. Dense fog and pouring rain made it tough hunting.

Teams of the Royal Canadian Mounted Police, the Royal Canadian Air Force, forestry crews and civilians waded through swamps and thick black spruce. At mid-day yesterday the air force helicopter spotted the boys about five miles from their camp and landed the pontoon-equipped whirlybird on a nearby lake.

Elwood Lewis, camp director, phoned Dr. and Mrs. Chester J. Schmidt, Kenneth's parents, at 7:50 PM Tuesday to tell them the boys were missing. Vorisek, a physician, called the other parents.

"It put me in a state of shock, a feeling of helplessness," said Mrs. Chester J. Schmidt. Her husband said, "At first I thought, 'Ah, he'll pull through.' But later I got pretty depressed. You sit there and think, you know? Then I tried to sleep last night (Tuesday) and all I could see were mountains and swamps."

Mr. and Mrs. Brian D. Evans did not sleep at all Tuesday night, said Mrs. Evans. "We stayed up and worried," she said. "I tried to read but I couldn't. So I just sat."

The five boys, pronounced fit by a doctor, said they wanted to finish their July 1-31 camping trip and their parents agreed. The camp is owned by Sherman Pratt of Locust Valley.

G.A

CANADIAN GUIDES AND MENTORS. Shown in 1968, Canadians Herman Matchett (left) and Hubert Holmes (right) were an integral part of the program and a big help during the boys' misadventure. Matchett served the camp as a trail guide from 1961 through 1976. A lifelong employee of the Pratts, Holmes was universally admired and known to every camper. In December each year, he delivered Christmas trees to Locust Valley for the club's holiday sale.

LOOKING BACK. The remaining years of camp were peaceful and uneventful. In 1976, at the urging of the Canadian government, the Pratt family relinquished their fishing rights to Holmes Lake, and Canadian Camp came to an end. Alumni look back at these fun-filled months with nostalgia and affection. Gathering to swap stories with fellow Canadian Campers has become an annual event. Alumni fondly remember earning service points to secure their spot, choosing a fishing hat for both function and style, and enduring the long bus ride north. Along with the many friendships made, adventures shared, and opportunities enjoyed, they recall hiking, camping, canoeing, fishing, canoe jousting, waterskiing, and more. Memories of ending each day with card games, campfires, songs, and stories only add to "the sheer beauty of the landscape indelibly etched in their minds."

Four

ACTIVITIES AND EDUCATION

Much of the fun enjoyed at the club happened in the games room. For many, this was the place to hang out with friends and hone one's skills as a card shark or chess master. Upon arrival, boys presented their membership cards to check out items needed to play checkers, billiards, Ping-Pong, and more. Competition was particularly stiff during intraclub tournaments. Winners in each age group represented Grenville Baker in tournaments against other clubs. They also received recognition each year at the Banquet of Champions, earning a special club shirt.

As executive director, William Hinckley considered it his responsibility to foster a sense of inclusion at the club through positive engagement. To that end, the club offered a wide range of activities beyond athletics to capture the interest of as many boys as possible. On a practical level, this required some ingenuity. Hinckley became a master at finding a source of equipment or funding where needed. With his homespun pragmatism and ability to draw each listener into his next story, donors found it hard to resist his enthusiasm.

Club activities soon grew beyond the games room to include rifle practice, bicycle repair, model airplanes, and shop class, to name a few. Through generous donations, arts and crafts were augmented with photography when a darkroom was included in the first addition. Boats were made available for seamanship training, and local mechanics and repair shops provided tools and assistance to boys eager to learn. As the club grew, the list of activities offered changed to reflect the changing times and interests of the club's membership.

From its earliest days, boys received help at the club with their homework. Hinckley understood that many members came from families who worked on local estates and had little education. "They can't always offer help to their children," Hinckley explained, "so the club helps out."

AFTER-SCHOOL GAMES. Beginning in 1950, the games room was the club's most popular destination throughout the year. The basic rules about sharing and taking turns were understood by members and rarely required enforcement by staff. This small pool table, cue sticks, and balls, like much of the club's early equipment, was a generous gift from an anonymous community member.

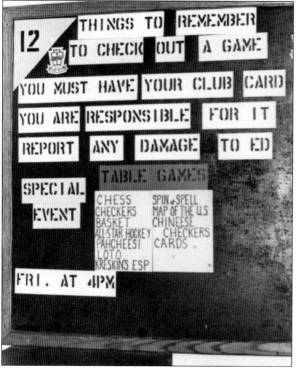

HANDLE WITH CARE. In addition to billiards, games room equipment included table tennis paddles, nets, and balls; boards and pieces for checkers, Chinese checkers, chess, and dominoes; shuffleboard cue sticks and discs; along with bean bags, darts, table games, and cards. Although well-used and somewhat worn, each piece of games room equipment was indispensable and not easily replaced.

Member Card. Every boy was issued a member card printed on Masonite board. Members received a new card only when they moved up in the age-ranked membership categories: midgets, juniors, and seniors. Members obtained their cards upon arrival and used them to check out books, games, and sporting equipment, returning them at the end of the day. If one went home with their card, they were fined one nickel.

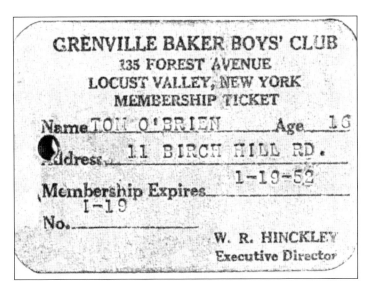

GRENVILLE BAKER BOYS' CLUB
135 FOREST AVENUE
LOCUST VALLEY, NEW YORK
MEMBERSHIP TICKET

Name TOM O'BRIEN Age 16

Address 11 BIRCH HILL RD.
 1-19-52
Membership Expires
 I-19
No.

W. R. HINCKLEY
Executive Director

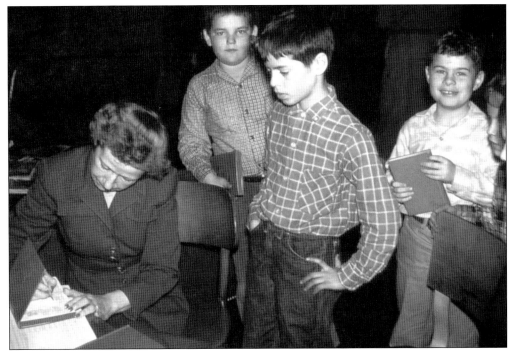

Sign Out. Whether in the library or the games room, each boy presented his membership card to sign out books, games, or equipment and then was responsible for their return. In keeping with the club's mission, this simple process provided an opportunity to reinforce a sense of responsibility in each young member.

BOARD GAMES. The games room tournaments were divided by age into midgets, juniors, and intermediates and followed a monthly schedule. For board games, the checkers tourney was in January with chess in March. The number-one goal for these tournaments was fun, but they also had the additional benefit of providing an arena beyond athletics for all boys to enjoy the benefits of camaraderie and competition.

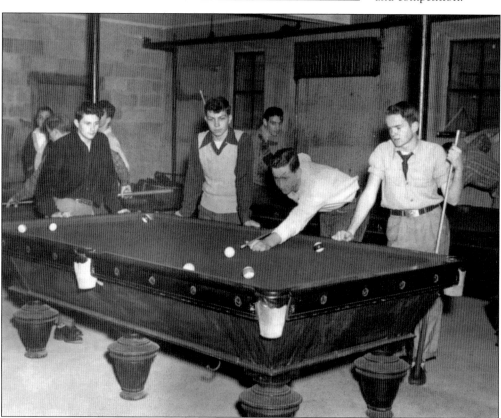

POCKET BILLIARDS. At the club, the pace of play at billiards often set the stage for more friendly banter than feats of skill. But during the club's billiards tournament in February, matters became more serious. Top scorers were eager to compete with other clubs where stakes were high, and winners received awards that included sports equipment, radios, cameras, and other prizes.

LAWN SPORTS. Even in the colder months, horseshoes, whiffle ball, and ball hockey brought determined competitors outside. What better way to burn off youthful energy than by making use of the wide-open field behind the clubhouse. Weather permitting, the staff encouraged outdoor play. Spontaneous and self-directed, the boys determined the rules of their games, not requiring the close supervision of an organized sport.

FIERCE COMPETITION. Each winter, the boys who won the intraclub tournaments became part of the club's games room travel team and played other clubs' teams throughout New York City. In 1953, Grenville Baker's games room team took first place when they traveled to Madison Square Boys Club to participate in a citywide tournament at table tennis, chess, billiards, checkers, and shuffleboard.

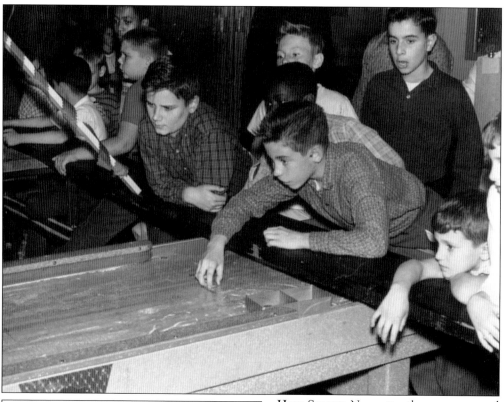

HIGH STAKES. No matter the game, a crowd always gathered, loudly and enthusiastically commenting on the odds and the outcome. While waiting their turn, these amateur coaches loudly offered unsolicited, often conflicting advice on game strategy and shot selection. For players, spurred on by the cheers and jeers, winning these after-school games often rose to the importance of the World Series or even the Stanley Cup.

```
         G A M E S   R O O M   C H A M P I O N S

    Checker Champions              Table Tennis Champions

Midget        Jerry Galasso    Midget        Jerry Galasso
Junior        Guy Caruso       Junior        Fred Simons
Intermediate  Andy Young       Intermediate  James Galasso

    Billiard Champions                Chess Champions

Midget        Chris McCormick  Midget        Jerry Galasso
Junior        David Cameron    Junior        Tom Tohn
Intermediate  Andy Young       Intermediate  Ronald Hinckley

   Shuffle Board Champions      "Rolla Bolla" Bowling Champions

Midget        John Cameron           Midget League
Junior        Jerry Galasso          (age 8-9-10 )
Intermediate  George Difede             Bullets

                              Jerry Galasso    Bill Gorman
                              Joe Capobianco   Joe Maccarone

                                 Intermediate League
                                    (age 13 - 16)
                                      Kingpins

                              Jim Galasso     John Kelczewski
                              John Sury       William Cameron

        NEW YORK CITY CHECKER TEAM CHAMPIONS

           GRENVILLE BAKER BOYS' CLUB

     Midget           Junior           Intermediate

Jerry Galasso    Guy Caruso       Andrew Young
James Eliseo     Henry Banach     Robert Mollitor
Tom Capobianco   Ralph Eliseo     Joseph Cucci

   Individual Honors - New York City Checker Tournament

            Jerry Galasso    1st place
            Andrew Young     2nd place
            Guy Caruso       2nd place

 Individual Honors - New York City Table Tennis Tournament

            James Galasso    3rd place

          Operation Juvenile Decency
```

GAMES ROOM CHAMPIONS. Both intraclub tournaments and interclub competitions were taken seriously. In keeping with the club's philosophy, the names of games room champions were posted in the clubhouse and recognized at the club's annual award ceremony, the Banquet of Champions. With the continued loyalty of the editor and club cofounder Edith Wyckoff, the winners received weekly recognition in the *Locust Valley Leader*.

BANQUET OF CHAMPIONS. The Banquet of Champions was a highly anticipated highlight of the year, celebrated in April at the end of the national Boys Clubs of America Week. The dinner and awards ceremony afforded a chance for the club to recognize and applaud the achievements of its young members. The club also honored and thanked the many adult volunteers for their hard work throughout the year. Sometimes, a local celebrity would be acknowledged, like Locust Valley resident and 1956 Olympic Gold Medalist rower Charles Grimes or Manhasset All-American and 1959 Cleveland Browns star Jim Brown. In 1960, the occasion was particularly festive with the undefeated Long Island Division III Champion Midget Varsity football team in attendance. Below are, from left to right, team members Tom Colgrove, David Bambey, and Harris "Skip" Luscombe.

LIFELONG FRIENDS. William "Birdie" Kinnear (left) and Louis "LouDel" Della Vecchia (right) enjoy a moment at the Banquet of Champions with their wives, Jane (left) and Jeanne (right). Kinnear and Della Vecchia shared many things in common. Two Locust Valley natives, they were early members of Grenville Baker. As young men, they served in the military, Kinnear in the Navy and Della Vecchia in the Army. Having loved their time at the Boys Club, they each decided that making a difference and having a positive impact on youth was the profession for them. Upon returning to Locust Valley, they began working at Grenville Baker, married local girls, and started families. In their spare time, they opened a sporting goods store together on Forest Avenue called Valley Sports Center. After leaving Grenville Baker, they each went on to careers as executive directors of Boys and Girls Clubs: Kinnear in Columbus, Ohio, and Della Vecchia in Newport, Rhode Island.

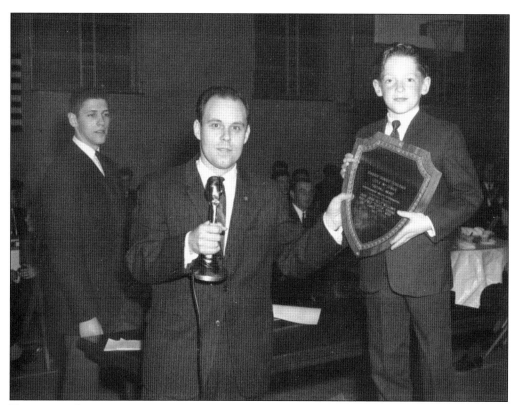

EXCELLENCE ACKNOWLEDGED, 1962.
With the club's Boy of the Year
William Posch (left) assisting, Woody
Lewis congratulates Jim Eliseo, winner
of the Harris "Jumbo" Luscomb
Award for "sportsmanship, ability
and determination." Later that
evening, Posch was also recognized as
Boys Clubs of America's New York
State Junior Citizen of the Year for
outstanding service to his home,
church, school, community, and
Boys Club.

PHOTOGRAPHY. With the
encouragement of Sherman Pratt, the
club's 1956 addition included a dark
room. Boys, ages 11 to 18, were taught
how to develop and enlarge their
own pictures. The Photography Club
became so popular, the boys needed
to use the equipment in shifts. Several
Club members received recognition
from the Boys Clubs of America
Photography Contest each year.

FISHING. In the spring of 1964, warmer weather made it possible for the boys to fish on the Long Island Sound, taking part in flounder fishing contests in Glen Cove and fishing derbies off the Creek Club beach. The boys learned all the basics of fishing, from the care and maintenance of their fishing tackle to cleaning and cooking their catch.

SEA SCOUTS. In 1955, seamanship was added to the club's programming for intermediate and senior members. Robert Gunther, a commissioned officer in the Navy and the Brooklyn Power Squadron, became the instructor. In addition to sailing on Gunther's sloop, the Sea Scouts' winter project included repairing a rowboat. By 1960, generous patrons had donated several sailing vessels for them to use, plus a cabin cruiser to sell.

TURKEY SHOOT. Each year before Thanksgiving, the club sponsored a turkey shoot and the *Leader* posted a warning telling neighbors not to be alarmed if they heard gunshots in the vicinity of the Boys Club. Oscar Hammel, the proprietor of Birch Hill Market, donated the turkeys for the event. Three lucky sharpshooters brought home 20-pound turkeys for Thanksgiving. By 1974, the turkey shoot was a coed activity.

BOWLING LEAGUE. On alternate Saturdays during the 1960s, the club sponsored tournaments and a bowling league with team names like the Strikers, the Splits, and the King Pins. In 1964, the *Leader* noted that the tournament winners were Ed Aromski, George Shaddock, and Mike McCormick. Bowling became part of coed Saturday night activities, which also included dances, pizza parties, and movies.

CHEF'S CLUB. A cooking class began at the club for boys aged 12 and older in 1959. Classes were taught by expert cooks, and boys learned the practical skills of shopping for food as well as planning and cooking meals. Shown above in his white Maine Sardine Seacook apron, Ralph Eliseo won the top prize in a contest for his sardine stuffed tomatoes recipe. For the Chef Club's grand finale, the boys cooked and served their parents dinner. A decade later, the club also incorporated a fishing trip followed by lessons on how to prepare and cook one's catch. Seen below, the Chef's Club marches proudly in the Memorial Day parade.

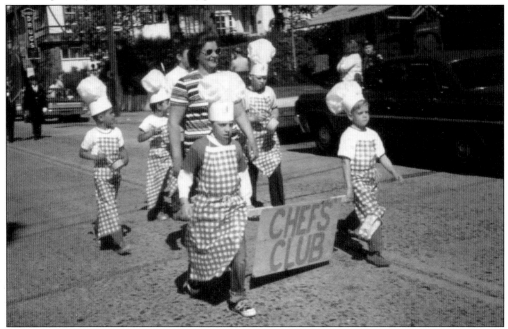

SHOP. The 1956 addition also provided a shop for boys who were mechanical and creative and wanted to work with their hands. Locust Valley resident James Dick began a shop program at the club offering woodworking, ceramics, copper craft, leather craft, plaster molding, and basketry. In the month before the Banquet of Champions each year, boys worked diligently in shop making ceramic ashtrays as thank-you gifts for their coaches.

MODEL AIRPLANES. In 1958, Thomas Gilliams, age 10, constructed a model plane in shop. By the following year, the club expanded the program. Directed and funded through the generosity of local resident Martin Widdifield, the club received the radio controls, gas engines, fuel, and tools needed to instruct boys in the art and science of building radio-controlled model airplanes.

V EIGHT CLUB. A speeding ticket and a love of fixing cars were the prerequisites for joining the V Eight Club. Once they found garage space in 1956, members enjoyed taking old cars and turning them into hot rods. However, the group was governed by a tough set of bylaws. Boys could only stay in the club if they stayed inside the law. No more speeding tickets allowed.

CERTAIN SET OF SKILLS. In addition to cars, the V Eights used their mechanical ability to fix up discarded bicycles at Christmas, giving a refurbished bike as a present to kids who could not otherwise afford one. Over the years, the Boys Club also sponsored dune buggy, mini-bike, and go-cart clubs depending on the level of interest among the membership.

MUSICIANS WANTED. Music appreciation and performance were added to the list of activities at the club in 1957. Enjoying a place where they could practice without being asked to pipe down, members of the club brought in their instruments and their talents, providing a much-needed band for Saturday night dances.

BOBBY HAMILTON. At age nine, Robert Caristo and twin brother Ralph joined the club in 1950. A member of the travel basketball team, Caristo remembers singing on the bus ride to games. By age 17, he was traveling and singing professionally and appearing on Dick Clark's *American Bandstand* after he wrote and recorded the top-100 hit song "Crazy Eyes for You" under the stage name Bobby Hamilton. (Courtesy of the Caristo family.)

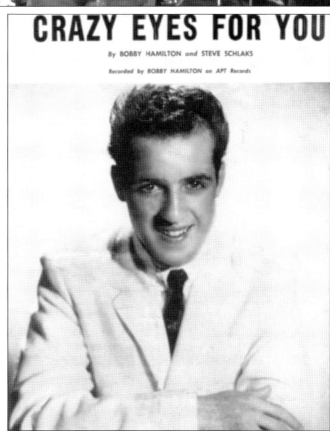

CRAZY EYES FOR YOU

By BOBBY HAMILTON and STEVE SCHLAKS

Recorded by BOBBY HAMILTON on APT Records

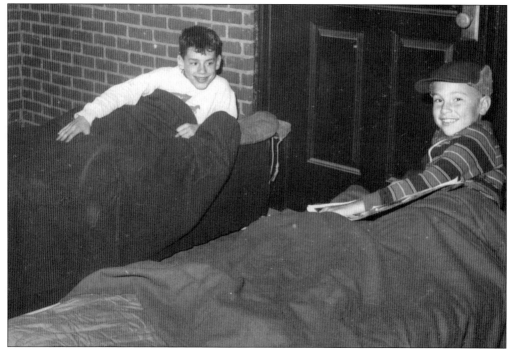

STAMP CLUB. A Stamp Club was formed in October 1957 with Rev. John Dykstra as the advisor and the assistance of William Hinckley and William Cullum. The club met in the library on the first Thursday of the month. The call went out to the community for the donation of stamps to help the boys get started. After the first year, Jerry Dykstra received first-prize honors and recognition at the Banquet of Champions for his collection of national park stamps. In October 1960, two members of the Stamp Club, Warren Kuhlewind and Danny Jewell, slept outside the Locust Valley Post Office all night to be the first to purchase the commemorative 4¢ stamp honoring the Boys Clubs of America from postmaster Dudley Merritt.

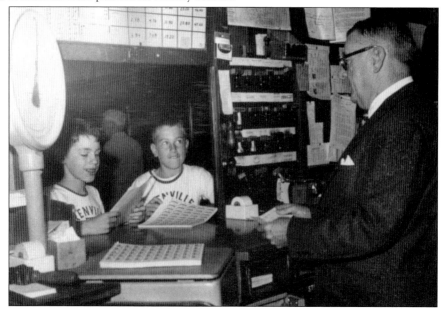

TUG OF WAR. In 1966, the Presidential Fitness Challenge was taken very seriously by every school-age child. Scrupulous records were kept of each individual performance, from sprints to pull-ups to push-ups. On a rainy day in summer, a spontaneous tug-of-war in the gym provided a non-Presidential Fitness Challenge, testing each participant's strength and teamwork. Sneakers were optional.

BUBBLE-O-METER. Careful measurements by William Hinckley determined the winner of the bubble gum contest. Extra points were given for bubbles that kept their round shape and blowing the tricky "bubble inside a bubble." Points were taken off for popped or drooping bubbles. A good deal of technique went into arriving at the perfect bubble, requiring determination, lung capacity, and multiple trips to Kramer's to purchase gum for training purposes.

MASS TRANSIT. When New York City was the destination, the best way to transport a large group of boys was often public transportation, whether to a museum, ballpark, or zoo. Fortunately, the train station abutted the club's playing fields, and walking over to catch the train was easy.

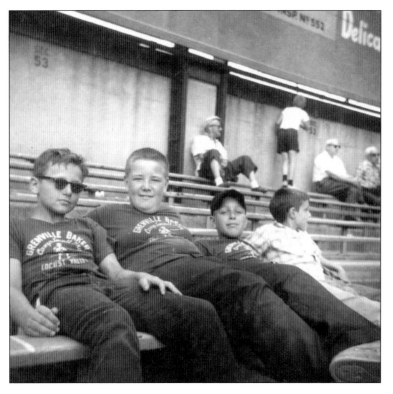

FRONT-ROW SEATS. An important benefit of the club for many boys was the chance to see new places. On a sunny day at the ballpark, club members enjoyed the change of scene. Here, Ed Snyder (far left) and Rich "Dew Drop" Mollitor (second from left) happily sit back and relax, hanging with friends, watching a ball game, and hoping for "some peanuts and cracker jacks" and possibly a hot dog or two.

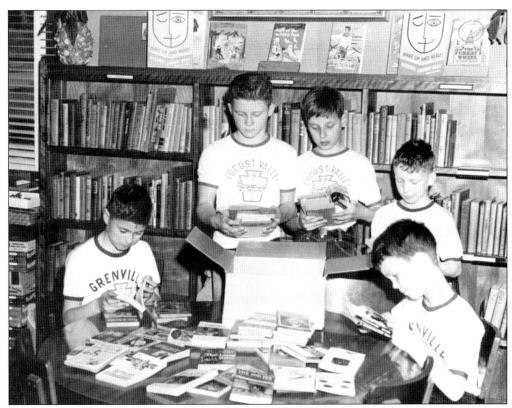

CLUB LIBRARY. In 1957, the club opened a new library with the help of the Women's Auxiliary of St. John's of Lattingtown. The library was staffed by a group of volunteers from several community organizations, including the Reformed Church, the Parents' Club, and the Locust Valley Woman's Club. In 1958, a librarian, Ellen Bartolotta of Bayville, was hired for afternoons.

HOMEWORK HELP. In addition to recreation and athletics, from its earliest days the club offered a quiet place for homework in the clubhouse library. For some members, it afforded them the opportunity to get their schoolwork done early before participating in programs or socializing with friends. For others, it provided much-needed assistance with their studies.

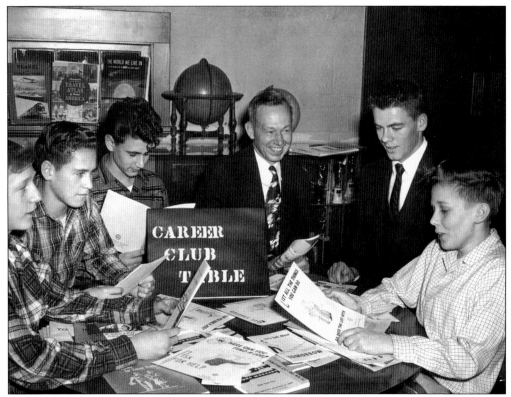

LOOKING TO THE FUTURE. In 1957, a Career Club began to provide direction to teen boys through a guidance counselor, guest speakers, and films on various fields of employment. A forerunner to the club's College Prep program, the Career Club encouraged members to prepare for their futures and to work toward a collegiate degree to meet their career goals.

FIELD TRIPS, 1961. From left to right, Leo Della Vecchia, Hank Roberts, and Dick Mollitor (in back), Pepsi Crown Contest winners, visited Pepsi-Cola Company's sugar loading dock across the East River, New York City, from the United Nations. In Pepsi's modern control laboratory nearby, the boys were able to examine ingredients and see firsthand how Pepsi's soda pop was made.

Five

THE GIRLS CLUB

Although women played an important role in the founding of Grenville Baker Boys Club, in 1950 the membership did not include girls. At that time, the dangers of juvenile delinquency were considered much greater for boys than girls, and providing a safe place for boys was considered a priority. The club's national sponsor, Boys Clubs of America, also excluded girls.

Beginning in the early years, however, the club included girls in coed social activities such as field trips, movies, bowling, and dances. As women and girls began to break barriers, athletically, academically, and professionally, the idea that girls also deserved and needed a "place to go, to grow, and to have fun" gained strength and support.

By 1968, in response to a petition signed by more than 200 local girls, Grenville Baker's board agreed to establish the Girls Club of Locust Valley with plans for separate personnel and facilities. The petition was entrusted to Grenville Baker board member Louise Craigmyle, who worked to incorporate the Girls Club of Locust Valley, established a board of directors, and became its first president.

Craigmyle rallied many of her friends to raise the money needed to purchase a clubhouse on Forest Avenue and to hire a full-time director. A request went out for volunteers, financial support, equipment, and furniture. The Girls Club became an affiliate of Girls Clubs of America and with a great deal of effort, the fledgling club was launched. Programming included recreation, music, crafts, and cooking.

As the disparity between the resources and facilities available to boys and girls became evident, there was a movement in the town and on the Boys Club's board to level the playing field and bring the boys and girls together. On May 20, 1981, Grenville Baker Boys Club and the Girls Club of Locust Valley merged to form Grenville Baker Boys and Girls Club. To accommodate this increase in membership, a new addition was constructed and dedicated in 1983. The national organization made the change nine years later, forming Boys and Girls Clubs of America.

LOCUST VALLEY GIRLS. In 1951, a group of girls tried to create a girls' club in Locust Valley, but there was meager community support. Some efforts were made to share the Boys Club facilities with girls. In 1959, girls were offered a $1 per annum limited membership that entitled them to use the library in the afternoon and evening, attend roller-skating sessions, and participate in other activities on the main floor.

DANCE, 1962. Director Bill Hinckley did his best to encourage coed social activities at the Boys Club, including ski trips, volleyball games, bowling, ice skating, and roller skating often on a Saturday evening. The Mother's Club sponsored coed dances held in the club gymnasium. Pictured clockwise are Alex Barclay, Tom Vorisek, Joann Stimola, Mike Hunter, Cathy Lanzer, Tony Bollaci, Linda Douso, L.T. Henniger (hidden), Pat Waters, and Allison Birkins.

QUEEN EMILY, 1959. Emily Simons was the proud winner of the Little Sisters Contest. Club members escorted their younger sisters around the gym and then to the library dressed in their Sunday finest to await the judges' vote and learn who would be crowned. Emily's brothers, Charlie, Fred, Billy, and Eddie, were all active members of the Boys Club.

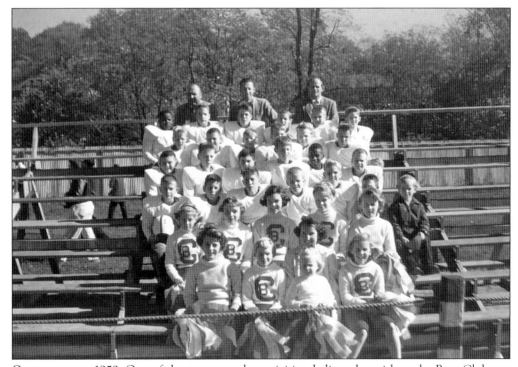

CHEERLEADERS, 1959. One of the most popular activities dedicated to girls at the Boys Club was cheerleading at the football games. The club provided uniforms, and coaches organized practice time. Tryouts were run by the Mother's Club. The squads not only performed at games, but also joined the boys marching in the Memorial Day parade.

PETITION DRAFT. In 1968, two hundred girls petitioned to establish a Girls Club. The petition was drafted on the back of a Carte Blanche billing envelope belonging to Thomas Hickey of Weir Lane. Director Woody Lewis and the Boys Club board agreed and the Girls Club of Locust Valley was incorporated. Louise Craigmyle, Helen Gibson, Helen Herzog, Stuart Johnson, and William Rabe were the official incorporators.

LOUISE CRAIGMYLE. Boys Club board member and fundraiser Louise Craigmyle became the first president of the Girls Club. As a young woman, she had been an accomplished singer and musician and was offered a screen test by MGM Studios. She married Ronald Craigmyle, later the mayor of Matinecock, and moved to Locust Valley to raise her family. (Courtesy of Harry McGinley.)

GIRLS ARE PRETTY IMPORTANT. In 1969, the Girls Club celebrated its new membership in the Girls Clubs of America. The Girls Club of Locust Valley was the first nationally affiliated girls club on Long Island. The new club moved quickly to establish a Parents Club and to begin fundraising. A request went out for volunteers, financial support, equipment, and furniture. With high hopes, the new club made plans for programming. Sports offered by the club were to include basketball, gymnastics, softball, and volleyball with practices and games at the Locust Valley Intermediate School. The club also hoped to provide outdoor activities, including archery, campcraft, swimming, and twirling guard. Indoor activities would include singing, dancing, dramatics, choral group, music lessons, needlecraft, sewing, cooking, and babysitter training. Classes in photography and journalism were also planned.

BOARD OF DIRECTORS

Chairman of the Board
Mrs. Ronald Craigmyle

President
Mrs. Thomas Mullarkey

Vice-President
Mrs. John McDonald

Vice-President
Mrs. George Murnane

Vice-President
Mrs. Beatrice W. Sutherland

Secretary
Mrs. William Kenny III

Treasurer
Mr. Edward Nielsen

Mrs. Jean Cattier
Mr. Donald Death
Mrs. Charles Eginton
Mrs. Stephen Ely
Mr. Robert Gardner, Jr.
Mrs. Robert Geddes
Mrs. Edwin Herzog
Mrs. Ralph Howell, Jr.
Mrs. Donald Little
Mrs. Edwin MacArthur
Mrs. Irving Meltzer
Mrs. Michael Pascucci
Mrs. Donald Shea
Mrs. R. Brinkley Smithers
Mrs. William D. Tabler
Mrs. John Williams

ADVISORY BOARD

Mrs. Robert Fowler
Mrs. Donald Janelli

MOTHERS' CLUB REPRESENTATIVE

Mrs. Thomas Flynn

THE HOUSE AT 168 FOREST AVENUE. Louise Craigmyle rallied her friends to raise the money needed to buy a clubhouse and to hire its first director, Virginia Dankel. A house was purchased one block away from the Boys Club at 168 Forest Avenue, Locust Valley. Much work was needed to make the house safe for the girls. In addition to paint, carpets, and furniture, they installed fire sprinklers and a second-floor fire escape.

POWER LUNCH. At the Piping Rock Beach Club, the Girls Club held an elegant, high-profile luncheon and fashion show featuring the latest fall couture from Gryphon of Locust Valley. A determined group of seasoned campaigners, the early board included Louise Craigmyle, Cleo Derigibus, Bronson Eden, Woodrow Gatehouse, Mrs. Donald Little, Leonard and Elizabeth Marshall, Mrs. Herbert Melley, and Mrs. William Rabe.

CHRISTMAS GIVING. To cover expenses, the members of the club fundraised and relied on board-solicited contributions and special functions. The club did not receive financial assistance from any other source, depending solely on community support to maintain its building and activities. Christmas cards designed by member Wendy Grissel, age 10, were sold as part of these efforts.

DIANE EMBREE. Success at their fundraiser inspired the girls and their instructors to try other creative endeavors. A former kindergarten teacher, Diane Embree taught crafts to the girls, often toting her toddler daughter Leslie with her. She and the girls found that using sliced apples dipped in paint to decorate tee shirts became their favorite project.

SWIM CLASS. A Mrs. Lyons taught swimming at the Craigmyle's pool. Christine O'Keefe (standing with arms crossed) smiles as she awaits her turn in the pool. A talented athlete, O'Keefe went on to break track records at Locust Valley High School. The club did its best to give every girl a chance to swim, even on a busy day, as seen here.

MARGE BUDDINGTON. Starting in 1974, Marjorie "Marge" Spence Buddington of Westbury (with hat) was the director of the club. Buddington was an active volunteer with the American Red Cross and Old Westbury Gardens before coming to Locust Valley. She actively recruited local volunteers to teach crafts and other activities and was the liaison between the club members and the board of directors.

BAKING FOR A CAUSE. Helen Rogalski headed the Dinner Club, where the girls used their skills to start an Adopt a Grand program, visiting and bringing cookies to the elderly at a nearby nursing home. In 1980, the program received an award from the Help Young America Campaign sponsored by Colgate-Palmolive Company. Of the 100 entries submitted, the Girls Club finished third for their project.

ACTIVITIES AND TRIPS. In addition to the after-school activities, the Girls Club also provided a summer day camp program with sports and sailing known as Camp Sunshine. Thanks to an anonymous donation of a station wagon, the girls took special trips, which included the Bronx Zoo and Radio City Music Hall.

CANDY BENJAMIN. Candy Benjamin supervises dressmaking classes, teaching the basics of sewing, by hand and by machine, on the second floor of the clubhouse. The first floor was comprised of Marge Buddington's office, the Everything Room, and the Hangout Room. Sewing took place upstairs, and the kiln was safely located in the basement.

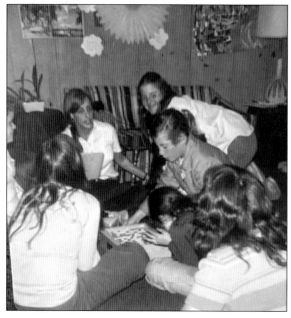

GAME TIME, 1973. Pictured clockwise are Peggy Scary (head down), Jill Coskiano, Sharon Soper, Carol Brennan, Janet Gazeley, and Margie Whitting gathered around one of the many board games in the Hangout Room. Having unstructured time to relax was as important as the lessons, practices, and programs and a huge draw to the club for many of the girls.

FAIR DAY. The girls staged activities like carnivals in the back of their clubhouse to help with fundraising. In addition to filling the coffers, the events provided an opportunity for the girls to demonstrate their creative art and design skills in building games and other amusements. Here, Rosa Daniello shows off the popular balloon dart board.

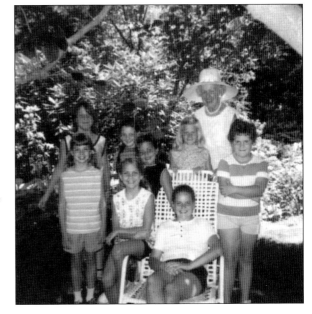

OPEN HOUSE. Louise Craigmyle (in white hat) remained involved with the youth of Locust Valley until the late 1980s, when she relocated to Florida. During her tenure as president of the Girls Club, she welcomed the members to her estate in the village of Matinecock for swimming classes and nature walks.

RED CROSS BABYSITTING, 1974.
Lorri Van Helden (in the
No. 12 green and white shirt)
receives her certification from
a Red Cross instructor upon
completion of the infant CPR
module, one of the most popular
programs at the Girls Club.
For those girls eager to earn
spending money, the job training
skills and certificate helped
them find babysitting jobs. The
lessons they received were both
practical and inspirational,
opening their minds to future
careers in medicine. They also
learned about the positive
impact of the Red Cross both
locally and around the globe. In
keeping with the club's goals, the
program sought to engage the
girls' interests while broadening
their horizons to include the
expanding and important role of
women in the world at large.

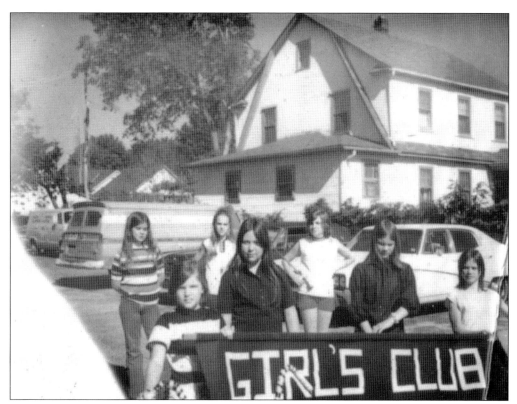

TALKS OF A MERGER. By the end of the 1970s, the Girls Club's house needed extensive repairs, and discussion of a merger began in earnest. Some fans of the Girls Club were worried, believing in the unique benefits of a special space for girls to encourage their self-expression, self-discovery, and creativity. However, the practical considerations of providing access to the facilities and resources of the Boys Club outweighed these concerns.

MAKING IT HAPPEN. Once the merger was agreed upon, the house at 185 Forest Avenue was sold to help fund an expansion of the boys' clubhouse to accommodate the addition of the girls. Pauline Boardman, the niece of Grenville Baker, chaired the 500-person Pink Ball held at the Creek Club to raise the extra money needed to complete the project.

BOYS AND GIRLS TOGETHER. While most of the social, educational, and games room activities could be coed, director Woody Lewis and the board agreed that it was important for the girls to have their own sports. The club added a girls' athletic director to the staff, and space was made in the club's schedule for the girls' separate practices and games.

A NEW SPACE. In 1982, an expansion designed by Locust Valley architects Maria and Fred Bentel and built by Locust Valley contractor Robert Weitzmann was completed. The two clubs officially merged ahead of the national Boys Clubs of America organization, which did not add girls until 1990, and Grenville Baker Boys and Girls Club was born.

Six

PAYING IT FORWARD

The hard work and generosity of the initial founders imposed a legacy of service on the club's membership, staff, and directors. Not only were they charged with the practical responsibility of maintaining the club's facilities and finances, but they were also charged with the greater task of upholding its spirit. From the outset, the boys were taught "to whom much is given, much is expected." With a strong sense of duty, they held themselves to high standards, expecting to give back and pay it forward to their hometown and beyond.

Many early members gave the ultimate service, joining the military and seeing action overseas. Locust Valley was particularly proud in 1950 when charter member Ziggie Kleckowski received a naval citation for bravery. Kleckowski dove into the Mediterranean to save an admiral and others whose aircraft had crashed off Crete. Other alumni of the club returned home to share their experiences abroad, inspiring the club to run clothing drives and fundraisers to benefit children in Korea and Vietnam.

Beginning with the club's first holiday season, the boys ran collections for local veterans and disadvantaged children. The club also encouraged boys to serve their community by looking for "the good and decent things that occur daily." In partnership with the local Legion Post, the club's TOF ("the other fellow") program recognized local people who cared for others.

In 1961, a severe storm struck New Brunswick, Canada, causing extensive flooding that destroyed roads, bridges, and farms. Boys who had attended Pratt's Canadian Camp circulated jars and held a Home Run Derby to collect donations for the New Brunswick Relief Fund. Their motto was "Let's help those who have helped us."

On a local level, the club gave back by sharing its fields, gymnasium, and meeting space with other community organizations. In 1964, the club extended an invitation across the country to other Boys Clubs hoping to see the New York City World's Fair. Visiting club members slept on bedrolls in Grenville Baker's gymnasium, expressing their appreciation for the "grand" accommodations.

CALL TO ARMS. In the fall of 1942, Grenville Baker did not return for his senior year at Harvard, enlisting in the US Army Air Corps. About 88 percent of Harvard's class of 1943 saw military service during World War II. By 1945, almost 24,500 former Harvard students served, of whom nearly 450 died, were missing, or were prisoners of war.

CROSSING THE DELAWARE. Patriotic Boys Club members turned a vintage Dodge truck into a "George Washington Crossing the Delaware" tableau for the July 4, 1976, bicentennial parade through Locust Valley. Post-parade, the community picnicked on the grounds of the high school and enjoyed fireworks sponsored by the Locust Valley Rotary.

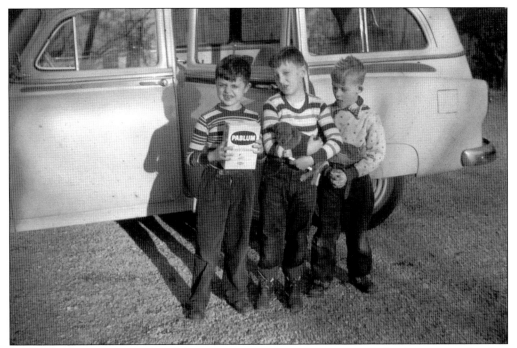

HELPING HANDS, 1950s. The club never missed an opportunity to help those in need, often partnering with another community group such as Operation Democracy. Admission to such events and gatherings was usually an item of food or clothing. The boys here guard their "ticket price" from their puppy. Pablum, known for its long shelf life, was a popular addition to overseas care packages.

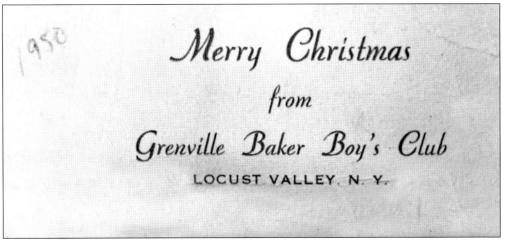

CHRISTMAS CHEER, 1950. With a brand-new clubhouse, the boys celebrated the club's first holiday season by decorating over 300 candy canes with cards and messages for placement on the breakfast trays of bedridden veterans at the Northport Veterans Hospital. The treats were delivered by Edith Wyckoff's mother, Helen Hay, and the Nassau County Red Cross.

GIRL SCOUTS. In keeping with the Boys Club's commitment to sharing with others and Bill Hinckley's plan to engage the greater community, the local Intermediate Girl Scout troop was invited to hold their meetings at the clubhouse. With the postwar population growth on Long Island, Nassau County saw the introduction of numerous local Girl Scout troops, and Locust Valley was no exception.

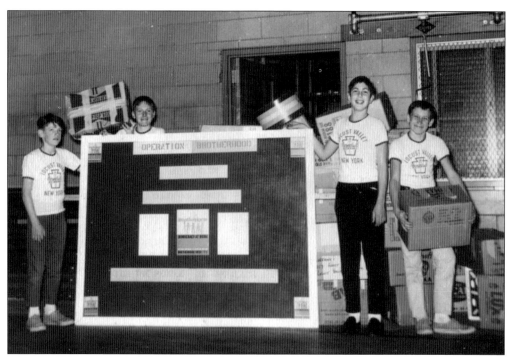

OPERATION BROTHERHOOD, 1950S. Operation Brotherhood was one of several programs embraced by the Boys Club to promote unity, camaraderie, and the spirit of service to other people in time of need. From left to right, Jim Eliseo, Gary Smith, John Wagner, and Bruce Vetro stand before the bulletin board promoting their latest collection drive for the people of Southeast Asia.

PRESIDENTIAL PHYSICAL FITNESS, 1968. Brinkley Smithers (left) and Woody Lewis (right) show off a banner proclaiming the club's commitment to this patriotic fitness program. The program scored high marks for including both field and gymnasium sports. According to Lewis, "We work with boys whose coordination is not highly developed. We work to give them confidence and prepare them to take part in competitive sports they might never enjoy without this program."

PIDGE MARTIN SCHOLARSHIP COMMITTEE, 1975. Pepsi-Cola executive Pidge Martin not only took the challenge of beginning a Boys Club in his community, but he remained involved until his death in 1974. To honor him, Pepsi-Cola funded a scholarship in his name. The first winner was John Cody of Locust Valley, a student at St. John's University. The scholarship was presented by club president Eric Ridder and Mary Martin.

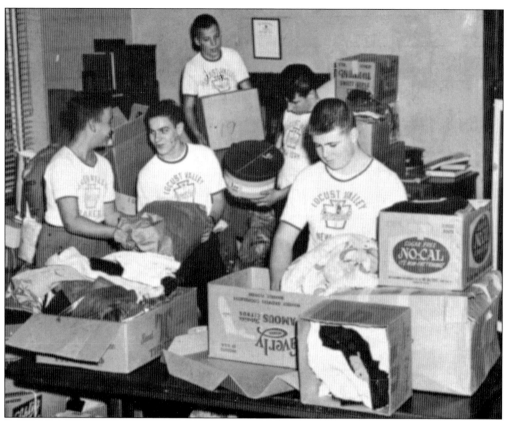

Do Bong Orphanage. Pictured are members of the Junior Citizens Club. From left to right are Ralph Panetta, Philip Rossetti, Dick Faber, Joseph Stimola, and Bob Mollitor packing clothing for the Do Bong orphanage in Kyunggi Do, Korea, in 1962. The American Korean Foundation presented a citation to the Boys Club at its annual Banquet of Champions for this effort. The award cited "for service to the Korean people in providing material aid in furthering the cause of international friendship." The club first learned of the orphanage from Maj. James Harrington (below, back row, third from left) of Locust Valley, who was a career Army officer. Harrington wrote home of the plight of the orphanage and appealed to friends and family for help.

FALLEN HERO. The eldest of Maj. James and Rose Harrington's six sons, James Harrington Jr. played sports at the Boys Club, excelled at baseball, and loved his time as a bayman out on the water. After graduating from Locust Valley High School in 1963, he enlisted in the Army, serving in Vietnam. Harrington reenlisted in 1967 hoping to keep his younger brothers at home. During his second tour, his platoon nicknamed him "Sgt. Hard Rock," for the guy who placed the wellbeing and safety of others before himself. In 1968, he was killed during a combat operation when a booby-trapped ammunition box exploded. Harrington received a Bronze Star with Oak Leaf Cluster, a Medal of Valor with Vietnam Campaign Medals, a Purple Heart, and Combat Infantry Badge from the Army, and a National Defense Medal and a Conspicuous Service Medal from New York State.

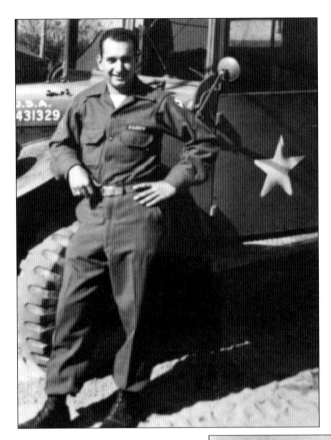

PAT ELISEO. A lifelong resident of Locust Valley, Pat Eliseo was a charter member of the Boys Club. He served in the Army during the Korean War. In addition to owning and managing Marquis Liquors, he served his community as Locust Valley's water district commissioner, fire department commissioner, Rotarian, blood drive chairman, and Matinecock Neighborhood Association director. Every October, he served donuts at the club's Spook Alley and Halloween parade. (Courtesy of the Eliseo family.)

VOTING REGISTRATION, 1953. In the midst of the Korean War, the Boys Club kept its focus on the positive aspects of democracy and was awarded for its efforts by the American Heritage Foundation. Fittingly, the award was designed by Polish American artist Arthur Szyk who recently immigrated to the United States. Szyk's World War II art was inspired by Roosevelt's 1941 "Four Freedoms" State of the Union speech.

Dear Citizen:

We, as JUNIOR CITIZENS, cannot vote.

But, that doesn't prevent us from being active in our Boys' Club's Community Service.

"GET OUT THE VOTE" PROGRAM

We urge you to be a good American.

We have faith in you as a citizen of the United States.

EXERCISE YOUR VOTING RIGHTS.

WE CAN'T, BUT YOU CAN—VOTE! NOVEMBER 8, 1960

GET OUT THE VOTE, 1962. The club conducted a bipartisan Get Out the Vote campaign in November 1962. The boys distributed pamphlets and posters to the merchants and citizens of the community encouraging them to vote. In addition, the boys staged a mock election for local, state, and federal officials. The program was part of the service and citizenship training programs at the Boys Club and at Boys Clubs nationwide. Below, volunteer Ralph Panetta supervises brochure distribution in Locust Valley. Panetta began caddying at Nassau Country Club when he was 13 years old. When he returned from the US Air Force in 1942, where he was a staff sergeant stationed in the Philippines during World War II, he worked at the country club on the weekends, then full-time after his retirement from Grumman. Panetta ran the pro shop and was renowned as a master clubmaker for his hand-carved golf clubs.

ALBANY, 1959. Ten-year-old Ralph Eliseo (white Boys Club shirt) visits Gov. Nelson Rockefeller as a finalist in the Boys Club Sardine Seacook contest, joined by two other contestants from New York State Boys Clubs. Eliseo also received recognition from the governor of Maine. As an adult, Eliseo went on to serve as a sergeant in the US Army in Vietnam, earning a Bronze Star Medal and Purple Heart Air Medal.

WASHINGTON, DC, 1963. In March 1963, members of the Junior Citizens Club traveled to take an educational tour of the nation's capital. They had worked on various projects throughout the year and sold Christmas wreaths to earn money for the trip. The Junior Citizens Club was part of the Cold War–era patriotism that swept the nation in the wake of World War II and the Korean War.

THANKSGIVINGS. Service to the community has continued throughout the years with the annual Thanksgiving basket drive for families in need. In addition to the turkeys shown, each basket contained potatoes, yams, canned carrots, green beans and peas, cranberry sauce, apple pie, and all the fixings for a holiday dinner. The basket was delivered to those who might otherwise do without. The club also hosted a traditional Thanksgiving celebration on the Tuesday before Thanksgiving with turkey, gravy, stuffing, and all the trimmings. The Keystone Club, the service and leadership club for high school students, assisted with the collection and distribution of the Thanksgiving baskets as well as the Tuesday evening dinners.

GUY'S POOL, 1971. Here are senior counselor Pete Sedlak (squatting) and campers Brian Evans (standing, left) and Ted Chevins (standing, right) at the Guy's Pool lean-to near Pratt's Canadian Camp. Evans followed in his brother John's footsteps, falling in love with his experience of the great outdoors at Canadian Camp. When the program ended in 1976, the Evans family generously welcomed the club to continue the camp at their property in Vermont. (Courtesy of Fans of Pratt's Camp Facebook Group.)

KEYSTONE REUNION. A culmination of the Boys Club's early service clubs, the Keystone Club is a national program of Boys and Girls Clubs of America that provides leadership development opportunities for teens. Participation focuses on academic success, career preparation, and community service. Many alumni of the program, like those shown at this reunion in 2022, grow up to become both active volunteers and community leaders.

Seven

TIES THAT BIND

"Of course we need the Santa Clauses," Eric Ridder, Olympic gold medalist and board member, said in 1965, "but it is important that the club be supported by everyone in the community." From its beginning, the club became a project not just of wealthy donors, but of the entire town. Businessmen, civic organizations, grandparents, parents, and children took ownership and were all proud. This pride and this ownership became a tradition passed down between generations of Locust Valley families.

After some initial skepticism about the viability of a Boys Club, residents wholeheartedly embraced its mission. Knowing enthusiasm was contagious, the club welcomed the entire community to attend sporting events, holiday celebrations, social gatherings, and more. Some of these occasions helped to raise money, but often it was also a chance to build awareness. Gifts in kind also helped. Each spring, William Hinckley picked up generous donations of games, furniture, bicycles, and athletic equipment from families eager to clean out their basements or attics.

In 1958, a Men's Club and a Mothers' Club were organized for parents eager to volunteer. The men served as coaches, organized an annual clambake, sponsored picnics, and provided transportation. The mothers cooked dinner for the Banquet of Champions, coached cheerleaders, and ran a pizza kitchen on Saturdays at football games. Over the years, these hardworking women went on to run the yearly clothing sale and sponsor an annual dance in the club's gymnasium.

In keeping with local history, residents gave of their talents, their resources, and their goodwill to meet the needs of the club. In turn, these fine individuals gained lifelong friendships and an invaluable sense of community. Their greatest gift to the young members of the club was not just the clubhouse and activities, it was also a strong sense of belonging. As charter member Pat Eliseo said, "As young boys, it was wonderful to know that our community cared and that we mattered." What an amazing legacy for the entire Locust Valley community.

LOCUST VALLEY
AND VICINITY

Copyright: 1960

Jim Colliery Associates
ADVERTISING
OYSTER BAY, N.Y.

LOCUST VALLEY, 1950S. After World War II, Locust Valley saw a rapid increase in its population with a diverse mix of full-time residents who both owned and patronized the local businesses. In 1948, the post office received a first-class delivery rating by doing business in excess of $40,000 in one year. To serve the community, new businesses opened with multiple grocers, gas stations, and clothing stores. The businesses and residents worked together to support the Boys Club, each to his own means and ability. Located at the center of the commercial district, the club became a focus and a symbol of community pride.

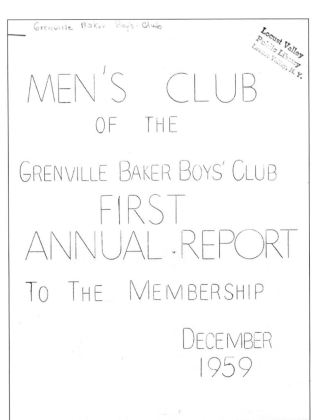

Grenville Baker Boys· Club

MEN'S CLUB

OF THE

GRENVILLE BAKER BOYS' CLUB

FIRST
ANNUAL REPORT

TO THE MEMBERSHIP

DECEMBER
1959

MEN'S CLUB, 1959. In 1958, fathers and friends joined forces to form the Men's Club. This energetic group of fathers and other local citizens rolled up their sleeves to help out around the Boys Club and to serve as coaches for baseball, football, track, and boxing. By 1960, the Men's Club had 75 members and was contributing 10,000 volunteer hours per year.

MOTHER'S CLUB. Formally organized in 1958, local mothers supported the Boys Club by providing refreshments at events, managing the cheerleading squads, and starting a sewing bee to repair torn uniforms. Any mother of a member who wished to volunteer at the Boys Club was welcome. Mothers are, from left to right, (first row) Gayle Hinton, Carol Shefers, Joy Marshall, and Paula Mastalerz; (second row) Lorraine Arominski, Priscilla Masterlez, and unidentified.

New Seating, 1956. The United Hunt Racing Association provided grandstands of metal and wood, worth approximately $10,000, to the Boys Club. The stands had been stored at the Piping Rock Club since they were last used for the Hunts Meet in 1942. A crowd of volunteers, including men and boys, put up the stands in time for a football game against Westbury.

Spectators. From left to right, Signe Fowle; Kevin Fowle; and his mother, Kristie Fowle, join the spectators on the sidelines of the Boys Club fields. Much of the Locust Valley community came together on Saturdays in the fall and spring, cheering on the football and baseball teams. The Boys Club was open for indoor activities as well, and the pizza kitchen, staffed by the Mother's Club, was always a popular draw.

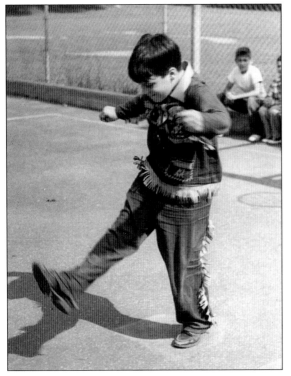

MEN'S CLUB FUNDRAISING. In 1959, over 600 boys enjoyed the Boys Club. Membership cost $5 a year, but the cost of providing each boy with the guidance, facilities, and programs at the club was $100 annually. It was widely believed to be "a sound investment" in the community, and attendance at events like movie screenings was large.

YOUNG DAVY CROCKETT. Either attending games or accompanying parents at pick-up, younger siblings welcomed the chance to spend time at the club. The club's family-friendly atmosphere was the best advertisement for the recruitment of future members. By the time they were of age, many little brothers were already familiar with the staff and vice versa.

SPOOK ALLEY. Spook Alley was the haunted house (or alley) the Boys Club created from the outdoor basketball court down the alley to the games room to "haunt, scare and enlighten those daring enough to follow the path of enchantment." It was limited to those under the age of 11 and staffed by older club members who came up with creative ways to "spook" the younger ones. One year, Buzz Simons spread cooked spaghetti on the floor to create a slimy journey. The Rotary Club of Locust Valley sponsored the annual Halloween party and invited all the children of Locust Valley. The festivities began with a parade led by a fire engine from the Locust Valley Fire Department followed by a costume judging contest.

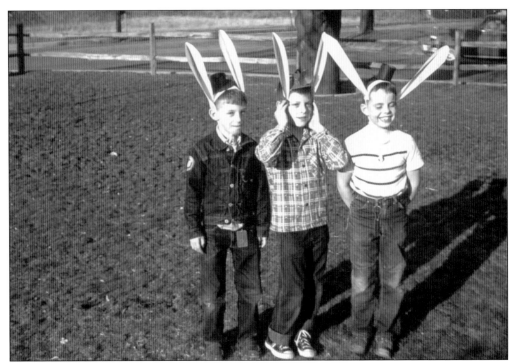

ART CLUB, 1961. The Boys Club's art club did seasonal projects as well as skill development, including the construction of bunny ears. The Boys Club and Rotary hosted an annual Easter egg hunt, drawing over 100 boys who searched for little chocolate eggs scattered on the athletic field. Twelve regular-sized eggs were designated as prize eggs, with the winners receiving large chocolate Easter eggs and bunnies.

LOCUST VALLEY FIRE DEPARTMENT. The Locust Valley Fire Department was an early supporter of the club. The department lent chairs for special events as seen here and occasionally flooded the outdoor basketball court for ice skating. In 1971, the club sponsored a junior fire tournament team called the Snoopy Raiders. At the end of their first season, they finished fifth out of 20 teams in state competition.

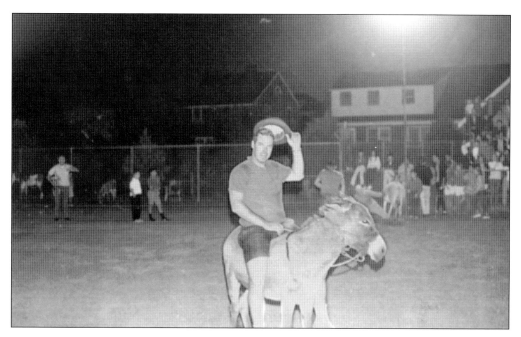

DONKEY BASEBALL. The Men's Club faced off against the Boys Club alumni in a fundraising game of donkey baseball. The donkeys were rented for the event, and it was a sellout game. When questioned, the Men's Club spokesman explained, "It's the same as baseball, only played on donkeys." There were several changes to the rules, including the "three falls off the donkey on your way to first and you are out" rule. To train for the big event, it was recommended that players maintain "a strict diet of oats and raw carrots." It was also noted that local pharmacists increased "their supply of liniment in anticipation of a large increase in business the day after the game." A second game was played in 1967, with the alumni taking on the Locust Valley Rotary Club.

GOOD FENCES. Bill Hahn (right) supervises Rob MacDonald (front) and another Boys Club member (back) on one of the many beautification/service projects the club members performed for the Locust Valley Community. In 1966, the Boys Club launched Anti-Litter Week, where the boys offered to paint garbage cans for local businesses. In addition, the Boys Club sponsored a poster contest, with Cathy Howard and Claude Thibaud winning prizes.

JANE HAHN. For more than 20 years, Jane Hahn worked as a club staff member while her husband, Bill, and his brother Brian were longtime volunteer coaches. In addition to her administrative duties, Jane created the club's scrapbooks and helped with the clothing sale for more than 30 years. Her many nieces and nephews have carried on the family's tradition of service to the club, including board member Holly Katz.

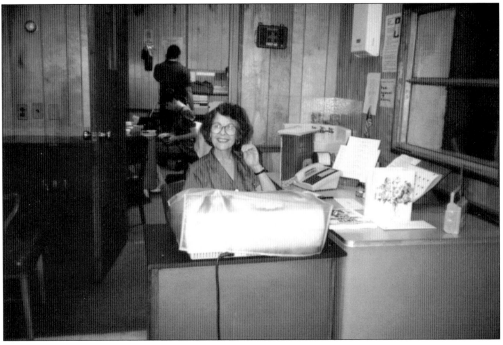

BILL DANIELLO. Bill Daniello was a member of the first graduating class of Locust Valley High School, where he earned the nickname "the Bull" on the football field. After graduation, he enlisted in the Army and played football for the National Champion Fort Benning Doughboys. A member of the Howard van Wagner Post 962 American Legion, Locust Valley Rotary Club (Paul Harris Award recipient), and Locust Valley Fire Department, he was inducted into the Grenville Baker Boys and Girls Club Hall of Fame in 2009. Right, Daniello poses for an official club photograph, and below, he is seen as a young man shepherding club members to a New York Jets game. From left to right are (first row), Jimmy Eliseo, John Cameron, Joe Maccarone, and Sandy Petzolt; (second row) Lou Della Vecchia, Dick Mollitor, Butch Soper, Jerry Nolan, and Daniello.

DOWN TIME. Ken Deecken (left) and Frank Giovinazzo (right) relax in the day room at Canadian Camp. While their schedule centered around the camp's many outdoor activities, the natural and positive by-product for the boys was the opportunity to forge lifelong friendships. Although they may have dispersed geographically over the years since, many Canadian Campers continue to maintain close contact with those friends through robust Facebook groups and well-attended reunions. (Courtesy of Ken Deecken.)

ANKER JOHANSEN. A charter member, Anker Johansen remembered the early days meeting at Edie Wyckoff's newspaper office. A proud Navy veteran, Johansen served Locust Valley's Rotary Club, American Legion Post, fire department, and water district. A loyal alum always ready to help the club by hanging banners or flags along Forest Drive, Anker was inducted into the Boys Club's Hall of Fame at the Leaders' Circle in 2014. (Courtesy of the Johansen family.)

ALUMNI GET-TOGETHERS. Charlie Savinetti jokes with Richard Staninger at one of the many informal alumni get-togethers. As part of its community outreach, the club opened its facilities for alumni and other civic groups to gather for sports, meetings, and other events. Early alumni formed pick-up basketball and softball leagues, often challenging the older boys at the club for bragging rights.

CHARITY SOFTBALL. Broadcaster and team pitcher Jim Jensen (center) gets ready for the annual charity softball clash between the CBS News All-Stars and the club's Over the Hill Gang. The All-Stars included former Yankee Jim Bouton and former Yankee and Met Duke Carmel. The club team included John Bergano, Lou Savinetti, Bob Weitzmann, and Buddy Winslow. The public gathered to meet the stars and get autographs after the game.

H. GRAY AND RUTH COLGROVE. A board member and a founding member of the Men's Club, Gray also coached and helped to organize the first annual Clambake. Ruth volunteered for the Mother's Club, June dance committee, and clothing sale. Gray became board president in 1978, presiding over the club's merger with the Girls Club in 1981. (Courtesy of Peter Colgrove.)

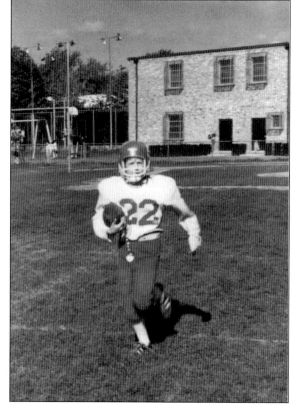

TOUCHDOWN, 1966. Peter Colgrove warms up on Cushing Memorial Field. Colgrove was a member of the 1967 varsity championship team in the midget league and remained involved with the Boys Club as an adult serving on the board alongside his father. The Colgrove family was inducted into the Hall of Fame in 2015. (Courtesy of Peter Colgrove.)

CLAMBAKE. Sherman Whipple was one of the originators of the annual clambake and each year supervised as the main chef at the affair. The first clambake in 1961 was held on Pratt's Beach and attracted 50 attendees. Eleven years later, it drew more than 400. For many years, the Colgroves' house on Horse Hollow Road was the staging ground, with equipment and food being dropped off all week. Chopping and prep work took place there on the day of the event to prepare a feast of lobsters, clams, and corn on the cob. Whipple oversaw the lobster pits and was widely considered the "father" of this annual function. The former owner of the Cabinetmaker's Shop in Locust Valley, he was an active member of the Village Players, serving as both producer and stage manager for the group.

CLOTHING SALE. In 1966, Tee Ridder, wife of board member Eric Ridder, hosted a clothing sale at their home on Feeks Lane. The *Leader* wrote, "A new kind of swapping is sweeping ye olde North Shore." With the help of Edith Baker, Barton Gubelmann, and Jane Boggs, the ladies organized a "nearly new" sale just in time for ladies to purchase dresses for the Boys Club dance. It was fun to "swap gowns" and to see who was wearing what to the dance. A huge success, it became an annual affair. By 1972, it moved to the club, where it was chaired for decades by sisters Carla Weitzmann and Alexandra Watkins, below, fourth and fifth from the left. At its height, it grossed $100,000 annually.

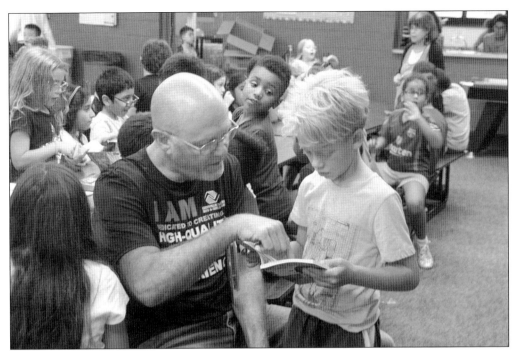

SETH WATKINS. "Mr. Seth" grew up at the club, where his mother, Alexandra, was a permanent fixture at the clothing sale. As an adult, Seth became a longtime member of the program staff, developing science programs that brought young members out to nature to experience the study of science outside the classroom. One participant recalled that she had so much fun on these outings, she did not realize she was learning.

PUNT, PASS, AND KICK CHAMPIONSHIPS. In 1971, Ford executive Tom Shanley congratulates John Stanisci for topping the 10-year-olds at the regional championships at Shea Stadium. Eight-year-old Ernest Scalamandre (No. 11) and nine-year-old Seth Watkins won their age groups as well. This was the first time all three regional winners came from one club. As adults, Scalamandre went on to join the club's board and Watkins joined the club's staff.

COLIN O'DONNELL. In 1979, the club's Youth of the Year, Colin O'Donnell, second from the right, was named New York State Youth of the Year. A rare achievement, the club is proud of O'Donnell and two other club members, William Posch in 1963 and Larissa Izaguirre in 2018, for achieving that honor. O'Donnell was also the first "club kid" to become board president and remains actively involved today.

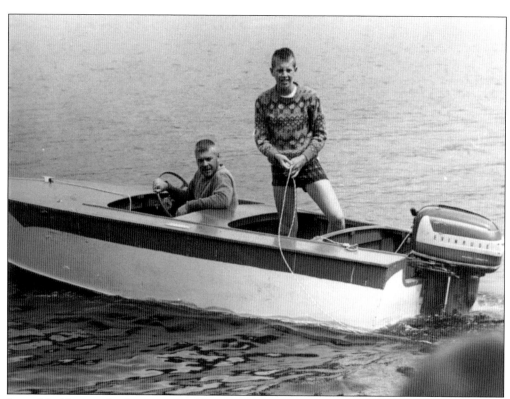

JAMES MACDONALD JR. Jim MacDonald joined the club in 1959, becoming active in midget varsity football. In addition to playing sports, he also traveled to Canadian Camp, where he enjoyed water sports, shown here standing with senior counselor Rodman Pellett. MacDonald went on professionally to maintain those same fields he played on as a club member and to serve on the club's board for 30 years.

DANCES AT THE CLUB. A set of fundraising dances sponsored by the Mothers' Club were held at the club itself. Here, Nancy Lewis (left), wife of Woody Lewis, and May MacDonald Iaconelli (right) pose before heading into the festivities. Both women were stalwart volunteers at the club, often staffing the pizza kitchen at the club on Saturdays. Along with her son Jim, May Iaconelli's daughter Barbara served on the club's board.

BOOSTER CLUB. Carl Adler, Frank Armstrong, and Doris and Frank O'Connor enjoy an evening out supporting the Boys Club. Armstrong and O'Connor were active in the Locust Valley Rotary Club and collaborated on joint projects between the two organizations. O'Connor spearheaded the Rotary's annual Thanksgiving feast at the club, fondly known as "Franksgiving," and intended to serve as a patriotic, family-friendly celebration for community members in need.

SWISH. Growing up around the corner from the club, George Shaddock would go straight there after school, returning home for dinner and then back again for more fun. He spent Saturdays there as well, in the games room and on the field. A versatile athlete, Shaddock went on to play varsity basketball at Locust Valley High School. He remains a font of local history knowledge and Boys Club lore. (Courtesy of the Shaddock family.)

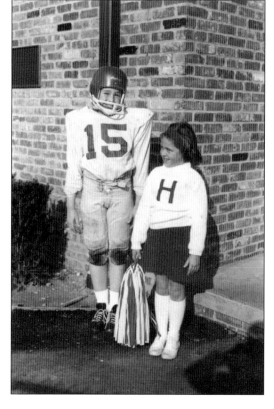

THE CRIMSON. George and Carol Schneider prep for a Saturday afternoon game. Sisters of players like Carol were placed on the same squads as their brother's teams. Their father, George Sr., was the postmaster at Mill Neck, where the family lived adjacent to the office. Young George took the railroad to the club for 25¢ per trip, making him a rarity among the bicycle and walking club commuters.

BILLY SIMONS, 1966. Although the fishing was just fair and the bugs especially bad at Pratt's Canadian Camp, the summer of 1966 was a happy one for Billy Simons (far right). Awards were presented for riflery, swimming, waterskiing, horseshoes, and more. Winning the cup for canoeing was particularly sweet for Simons. He clinched the honor during canoe jousting by overturning director Woody Lewis, a rare achievement. (Courtesy of Friends of Pratt's Camp Facebook page.)

ELISEO VICTORIOUS. The Eliseo brothers Jim (front, left) and Billy (front, right) stand before older brothers Tom (back, left) and Ralph (back, right) admiring their hard-won trophies and awards, especially Jim's Harris "Jumbo" Luscomb plaque for football. All the brothers were talented athletes who also participated and excelled in many of the Boys Club's other activities. Tom and Ralph were members of the stamp club, while Billy and Jim were pocket billiards champions. (Courtesy of Billy Eliseo.)

RICH HAGNER. In 1961, Rich Hagner (left) joined the club at age seven, participating in the athletic programs through high school. As a dad, Hagner coached many of his kids' teams, including Thomas's (center) baseball squad. As a board member, Men's Club president, and clambake chairman, Hagner exemplified the devoted alum. Fellow alumnus K.C. Callahan with his son Matt (far right) joined Hagner in both his coaching and clambake activities. (Courtesy of the Hagner family.)

KEVIN LOHRIUS. Kevin Lohrius joined the club at the age of nine. He loved sports and imitated Pete Maravich on the basketball court, right down to the socks. Lohrius has been a basketball coach at the club since 1987, beginning before his kids were old enough to participate and continuing with his grandchildren; his grandson Jackson stands with him wearing the white headband. (Courtesy of the Lohrius family.)

BRINKLEY AND ADELE SMITHERS.
Brinkley Smithers (right), the club's second president, was involved from the beginning as a board member and remained so until his death in 1994. Before World War II, he worked as a stockbroker, sales manager, and estate farmer, enlisting in the Army as a first lieutenant. Postwar, he recovered from alcoholism and established the Christopher D. Smithers Foundation to help others suffering from the disease. Adele Smithers served in the Air Force and worked in advertising and public relations. Following the death of her husband, Adele carried on the work of the foundation and his commitment to the club. A member of the board of overseers, she was presented by board president Patrick Mackey and executive director Ramon Reyes with the Boys and Girls Clubs of America's Service to Youth Award in 1996. (Right, courtesy of the Smithers Foundation.)

BOARD OF OVERSEERS. To effectively harness the rapid and continued growth of the club, Sherman Pratt recommended that a board of overseers be established to complement and to advise its board of directors. Pratt wanted to secure the future governance of the club and to retain the institutional knowledge and wisdom of older board members as they rotated off the board of directors to make room for the new.

PORTRAIT DEDICATION, 1970. Ethel Pratt and her daughter Deming unveil the portrait of Sherman Pratt painted by Madame Elizabeth Shoumatoff to hang in the club's new Sherman Pratt wing. After his death in 1964, the Pratt family remained steadfast and committed to the club, proud of the legacy he left behind for so many young boys and for future generations to come.

RONALD AND LOUISE CRAIGMYLE. Ronald and Louise Craigmyle were early backers of the club, with Ronald serving on the board and Louise working with the Mother's Club and at fundraising events. Louise transitioned over to the newly formed Girl's Club in 1969 as its first president and remained involved until the couple relocated to Florida. (Courtesy of Harry McGinley.)

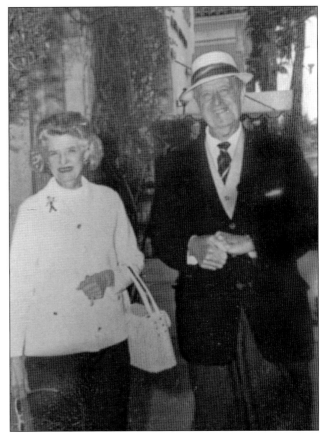

FAMILY AFFAIR. Robby Rhodes joined the club in the 1950s, becoming a lifelong volunteer in the ninth grade when he and his friend Tom Colgrove helped at the clambake. Once his kids Melissa and Rich became members, Robby joined the Men's Club. For the past 20 years, Melissa worked with several Boys and Girls Clubs and the national organization, recently returning to Grenville Baker to become the new executive director. From left to right are Rich Rhodes, Melissa Rhodes, and Robby Rhodes.

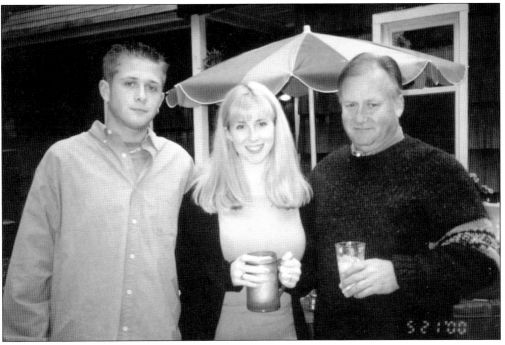

Discover Thousands of Local History Books Featuring Millions of Vintage Images

Arcadia Publishing, the leading local history publisher in the United States, is committed to making history accessible and meaningful through publishing books that celebrate and preserve the heritage of America's people and places.

Find more books like this at
www.arcadiapublishing.com

Search for your hometown history, your old stomping grounds, and even your favorite sports team.